Spencerian Handwriting

Spencerian Handwriting

The Complete Collection of Theory and Practical Workbooks for Perfect Cursive and Hand Lettering

Platt Rogers Spencer

Ulysses Press

Published in the United States by:
Ulysses Press
P.O. Box 3440
Berkeley, CA 94703
www.ulyssespress.com

ISBN13: 978-1-61243-528-2
Library of Congress Control Number: 2015944225

Printed in the United States by United Graphics

10 9 8 7 6 5 4 3

Acquisitions editor: Casie Vogel
Managing editor: Claire Chun
Editor: Caety Klingman
Proofreader: Darcy Reed
Front cover design: Double R Design
Cover images: background © MaxyM/shutterstock.com; pen © koosen/shutterstock.com
Interior design and layout: what!design @ whatweb.com

Distributed by Publishers Group West

Contents

Theory of Spencerian Penmanship
for Schools and Private Learners

DEVELOPED BY

QUESTIONS AND ANSWERS, WITH PRACTICAL ILLUSTRATIONS

DESIGNED TO BE STUDIED BY PUPILS IN CONNECTION WITH

THE USE OF THE SPENCERIAN COPY-BOOKS

BY THE "SPENCERIAN AUTHORS"

PUBLISHED BY

IVISON, BLAKEMAN, TAYLOR & CO.

NEW YORK AND CHICAGO

Introductory Remarks

Writing is almost as important as speaking, as a medium for communicating thought. For this reason it is said that "Writing is a secondary power of speech, and they who cannot write are in part dumb." Scrawls that cannot be read may be compared to talking that cannot be understood; and writing difficult to decipher, to stammering speech.

Signals

COMMENCING AND CLOSING WRITING EXERCISE

Remarks—In every properly conducted school, the writing exercise is commenced and closed in an orderly manner. The following plan is suggested, but it will, of course, be modified by the teacher as circumstances may require.

Pupils should obey the signals silently and promptly.

The teacher can frame special questions, and give the necessary drill to secure the desired order.

The signals may be given by bell, tap, or by counting, at the teacher's discretion.

OPENING

1. *Position at Desk.*
2. *Arrange Books.*
3. *Find Copy and adjust Arms.*
4. *Open Inkstands.*
 —In double desks the pupils on the left (the pupil's right) will open and close inkstands.
5. *Take Pens.*
 ☞ At this point the teacher should pay *particular attention to giving instruction in penholding.* When ready to write, give the order to "Take Ink."

CLOSING

6. *Wipe Pens.*
7. *Front Position.*
8. *Pass Pens.*
 —Collecting them in the reverse order of their distribution.
9. *Pass Books.*
 —Books are to be collected in the reverse order of their distribution.
10. *Close Inkstands.*

Position

POSITION FOR WRITING

Remarks—The position for writing should be a convenient one, allowing the easy action of the right arm and hand. In sitting at a desk or table there is little choice between what are known as the "Left-side," "Front," "Right-oblique," or "Right-side" positions. They are all practiced by writers; but it is well for the sake of order and uniformity in a class that all the pupils should observe the same position. Whichever method is adopted, those who do not wish to become hollow-chested or round-shouldered, should learn to sit easily upright, and keep the shoulders square.

As the free use of the hand mainly depends on the manner of holding the pen, the *correct* method only should be learned, and persevered in until it becomes habitual and easy.

FRONT POSITION AT DESK

1. Will you please describe and assume the Front Position at desk?

Sit directly facing the desk, near to it, without leaning against it, with the feet level on the floor, and the forearms resting lightly on the desk in front at right angles to each other. Let the right arm rest lightly on the muscle forward of the elbow—keep the wrist above the paper, and rest the hand lightly on the nails of the third and fourth fingers, which should touch the paper directly under the palm. Adjust the book so that the right arm will be at right angles to the lines on which you are to write. Hold the book in place with the fingers of the left hand.

NOTE—The "Left side Position" varies from the "Front" in having the left side inclined toward the desk, and in placing the arms and book on the desk further to the right, so as to bring the right arm at right angles to the edge of the desk. This position is the most favorable for writing on large books which cannot be turned obliquely.

RIGHT-SIDE POSITION

2. Will you please describe and assume the Right-side Position at Desk?

Turn the right side near to the desk, but not in contact with it; keep the body erect, the feet level on the floor; place the right arm parallel to the edge of the desk, resting on the muscles just forward of the elbow, and rest the hand on the nails of the third and fourth fingers, keeping the wrist off the paper. Let the left hand be at right angles to the right, and resting on the book, keeping it parallel with the edge of the desk.

NOTE—The "Right-oblique Position," varies from the full "Right-side Position" in having the right side but partially turned toward the desk, and the arms and book placed obliquely on the desk. It will be observed by trying the different positions that the greatest uniformity in a class can be secured by the full "Right-side Position." When a position has been decided upon, the pupils should be prepared to describe and assume it promptly.

HOLDING THE PEN

3. Will you assume the writing position at desk, and then describe the correct manner of holding the pen, conforming to it in each particular?

Take the pen between the first and second fingers and the thumb, observing, 1st, that it crosses the second finger on the corner of the nail; 2nd, that it crosses the fore finger forward of the knuckle; 3rd, that the *end* of the thumb touches the holder opposite the lower joint of the fore finger; 4th, that the top of the holder points towards the right shoulder; 5th, that the wrist is above the paper, and the hand resting *lightly* on the nails of the third and fourth fingers; 6th, that the point of the pen comes squarely to the paper.

Movements

Remarks—The venerable Platt R. Spencer, originator of the Spencerian System of Writing, said, "Our intention has been to present to the public a system,

"Plain to the eye, and gracefully combined
To train the muscle and inform the mind."

The training of the muscles of the arm and hand, by appropriate movement exercises, must be attended to. For, however distinctly a letter may be pictured in the mind, the execution of it on paper at all times depends on the control the writer may have over the muscles of the arm and hand. The will communicates its directing power through the numerous little telegraphic nerves, which descend from the brain—the direct organ of the mind.

In first attempts at writing, the muscles may not properly perform what the mind directs, but by frequent and careful practice they are rendered supple and obedient in the execution of every variety of form.

4. How many different movements may be employed in writing?

Four: Finger Movement, Forearm Movement, Combined Movement, and Whole-arm Movement.

FINGER MOVEMENT

5. Will you assume the writing position, describe the Finger Movement, and make it?

The Finger Movement consists in the action of the first and second fingers and thumb, and is used chiefly in making the upward and downward strokes.

EXAMPLES

NOTE—THIS movement should at first be made with the dry pen, as indicated in the cut; at the same time deliberately naming the strokes: Upward, Downward, Upward, or one, two, one, etc., etc. The Finger Movement alone is too limited for free writing; but will be found useful in combination with the Forearm Movement, as will be shown.

FOREARM MOVEMENT

6. Assuming the writing position, will you describe the Forearm Movement, and give an example of it?

The Forearm Movement consists in the action of the forearm upon its muscular rest near the elbow; the hand gliding on the nails of the third and fourth fingers. It may be employed in making strokes in any direction.

EXAMPLES

NOTE—This movement may be made as indicated by the cut, naming the strokes, thus: Forearm, Forearm, etc., or counting, 1, 2, etc., etc. The Forearm Movement is specially adapted to carrying the pen rightward, and leftward, across the paper, and is most efficient in combination with the Finger Movement, as will be shown. It is, however, used exclusively by some excellent penmen; the fingers and wrist being held firmly, to cheek their independent action. When so used the tips of the third and fourth fingers move in lines corresponding to those produced at the point of the pen.

COMBINED MOVEMENT

7. Assuming the writing position, will you describe the Combined Movement and give an example?

The Combined Movement consists in the united action of the forearm, hand and fingers, the forearm acting on its muscular rest as a center, and sliding the hand on the nails of the third and fourth fingers, while the first and second fingers and thumb extend and contract in forming upward and downward strokes.

NOTE—The combined movement may be first practiced by tracing the combined forms upon the page of Movement Exercises, or any convenient copy line, observing to use the forearm power in sliding the hand across the paper. This movement answers the requirements of business use better than any other: it combines the free untiring sweep of the forearm, with the delicate shaping powers of the fingers, securing ease and accuracy.

Finger Movement, or action of the 1st and 2nd fingers, with the thumb.

Forearm Movement, sliding the hand upon the nails of the 3rd and 4th fingers.

The accompanying diagram illustrates with tolerable accuracy the simultaneous action of the forearm and fingers, which constitutes the combined movement. Although the special office of the forearm is to transport the pen from left to right horizontally across the page, and the special part of the fingers is to execute the oblique upward and downward lines; yet, in practice, the two forces combine and assist each other. The forearm, particularly, will give to the fingers its firm, steady sympathy in the performance of their part.

WHOLE-ARM MOVEMENT

8. Assuming the witting position, will you describe the Whole-arm Movement, and give an example of it?

The Whole-arm Movement consists in the use of the whole arm from the shoulder, the elbow being raised slightly from the desk, and the hand sliding on the nails of the third and fourth fingers.

EXAMPLES

NOTE—The above capitals may be traced with the Whole-arm Movement, and the strokes regulated by counting, as indicated by figures. This movement is mainly used for striking large capitals. Its practice is highly beneficial, as it brings into free action all the muscles from shoulder to fingers.

Form

Remarks—The learner must have clear conceptions of the letters he wishes to form, before writing them. A few persons have the "imitative faculty" well developed, and can easily reproduce forms they have seen; but most need to measure, to analyze, to describe, and to trace, before they can copy with accuracy and grace.

The following practical testimony on the subject is perfectly conclusive, and we give it in preference to any farther remarks of our own:

> *"The Spencerian System of Penmanship was adopted by the Board six years ago, and its introduction was the commencement and the sole cause of a new and a better era of teaching the art of writing. Teachers, at first favorably prepossessed by the grace and beauty seen in all its forms, soon discovered that the most beautiful and artistic penmanship is susceptible of a full and definite analysis; that its elements, taken separately, are so simple that a child can comprehend them, and that they can be arranged, taught, and combined gradually and progressively, until a handwriting as perfect as the models in the text-book rewards the efforts of teacher and pupil. They learned from this system that teaching or learning to write is a mental as well as a mechanical process; that there must be thought as well as motion; that the prototype of every letter and every line, its exact form and proportions, must be so distinctly impressed upon the mind, that it can be described in precise and intelligible language before the hand attempts to execute. Where penmanship is taught in this manner success becomes a mathematical certainty. I have seen the copy-books of entire schools filled up with faultless penmanship, not a single one that was not superior to the best that was produced before the introduction of this system; and an oral examination upon the subject in such schools will interest as much as any exercise on the program for examination day."*
>
> —From Annual Report of the Superintendent of Public Schools of Washington, DC,
> November 14, 1871. Hon. J. Ormond Wilson

True theory and careful persistent practice are the means by which all may learn to write, with scarcely a limit to the degree of excellence. After a good handwriting is attained, and its use becomes habitual, letters, words and sentences will flow from the ready pen, with scarcely a thought on the part of the writer as to the manner of executing them.

9. *What is a line?*

The path of a moving point.

NOTE —These definitions relate to Penmanship and not to Mathematics.

10. *How many kinds of lines are used?*

Two.

11. *Will you name them?*

Straight lines and curved lines.

12. *Will you tell how to make a straight line, and give an example?*

To make a straight line, the point of the pen or pencil must be moved without change of direction.

EXAMPLE /

13. *Will you tell how to make a curved line, and give examples?*
To make a curved line, the pen must be moved with a continuous change of direction.

EXAMPLE

14. *How many different kinds of curved lines, and what are they called?*
There are two kinds of curved lines. They are called the *Right Curve* and the *Left Curve.*

15. *Will you describe a right curve, and make one?*
A right curve bends to the right of a straight line, connecting its extremities.

EXAMPLE

16. *Will you describe a left curve, and make one?*
A left curve bends to the left of a straight line, uniting its extremities.

EXAMPLE

17. *How many different kinds of lines are there with respect to position, and what are they called?*
Three kinds: Horizontal, Vertical, and Oblique or Slanting lines.

18. *When is a line said to be horizontal? Give an example.*
A line is said to be horizontal when it is level, or one end is no higher than the other.

EXAMPLES

19. *When is a line said to be vertical? Give an example.*
A line which leans neither to the right nor the left is said to be vertical.

EXAMPLES

20. *When are lines said to be oblique or slanting?*
When they are neither vertical nor horizontal.

EXAMPLES

21. *When are lines said to be parallel?*
When lines are equally distant from each other throughout their entire length, they are said to be parallel.

EXAMPLES

22. *What is an angle?*
An angle is the space between two lines that meet in a point.

EXAMPLE

23. *What is a right angle? Give an example.*

12 Theory of Spencerian Penmanship

The space between two straight lines meeting so as to form a square corner.

EXAMPLE ⌐

24. *Will you name different kinds of angles?*
 Right Angle, Acute Angle and Obtuse Angle.

25. *What is an acute angle?*
 The space between two straight lines meeting so as to form a sharp corner, or any angle less than a right angle.

EXAMPLE

26. *What is an obtuse angle?*
 The space between two lines meeting so as to form a blunt corner, or any angle greater than a right angle.

EXAMPLE

MEASURE OF ANGLES

27. *By what do we measure angles?*
 By the circle.

28. *How is a circle divided?*
 Into 360 equal parts, called degrees.

29. *How many degrees in a quadrant, or quarter circle?*
 One quarter of 360 degrees, which is 90 degrees.

30. *What angle does the vertical line form with the horizontal, as measured by the circle?*
 A right angle or an angle of 90 degrees.

31. *What angle is formed by a line drawn half way between the vertical and horizontal to the center of the circle?*
 An angle of 45 degrees.

32. *What do you call an angle of 7 degrees greater than that of 45 degrees?*
 An angle of 52 degrees.

33. *What do yow call an angle of 22 degrees less than that of 52 degrees?*
 An angle of 30 degrees.
 NOTE—The student should identify all these points and angles on the diagram.

34. *A line forming with the horizontal an angle of 52 degrees may be said to be on what slant?*
 On a slant of 52 degrees.

35. *A line forming with the horizontal an angle of 30 degrees may be said to be on what slant?*
 On a slant of 30 degrees.

36. *In what position are the written letters, vertical or slanting?*
 Slanting.

37. *To which side of the vertical do the letters lean or slant?*
 To the right.

38. *What is the slant of 52 degrees in the Spencerian writing called?*
 The Main Slant.

39. *Why is it so called?*
 Because it is the slant given to most of the main or downward strokes.

 EXAMPLE

40. *What is the slant of 30 degrees called?*
 The Connective Slant.

41. *Why called the connective slant?*
 Because a majority of the lines, connecting the main or downward strokes in the small letters, are made on the slant of 30 degrees.

 EXAMPLE

 NOTE—Measurements are given in this system as efficient aids to the learner in securing the correct forms of letters. The most of these measurements are exact, but in instances where an exact statement would involve a minute fraction, the nearest practical measurement is given, as the safest guide.

42. *What is the unit for measuring the height of letters?*
 The height of the small *i*, which is called a *space*.

 EXAMPLE, A B

43. *What is the unit for measuring the width of letters?*
 The distance between the two straight lines in the small *u* taken horizontally, which is equal to three-fourths of its slanting or angular height.

 EXAMPLE, C D

 NOTE—The difference between the height of *i* and the distance between the straight marks in *u*, is so very little—the latter being the less by only one-nineteenth—that it is hardly perceptible in writing of ordinary size. *It is, therefore, practically correct to consider the vertical space (the height of small i) as a standard for measuring both the height and width of letters.*

44. *How are strokes combined in forming letters?*

Angularly, by short turns, by oval turns, and by loops.

45. *How is an angular joining made?*

By suddenly stopping the motion of the pen at the end of a stroke, and uniting in a point with the stroke following.

EXAMPLES

46. *How is a short turn made?*

By moving from one stroke to another, as short as possible, without making a point, or stopping the motion of the pen. ,

EXAMPLES

47. *How are oval turns made?*

By increasing an oval curve near its end, so as to unite with its opposite side by a continuous motion, giving proper width.

EXAMPLE

48. *How is a loop formed?*

A loop is formed of two opposite curves, united by a short turn at one end, and afterwards crossing.

EXAMPLE

49. *Will you describe an oval?*

EXAMPLES

Direct Reversed Reversed
Oval Oval Oval

The general form of the oval is that of an egg. The ovals generally used in writing are elliptical, having ends rounded nearly alike.

50. *How many kinds of ovals are employed in writing, and what are they called?*

Two kinds—*direct ovals*, and *reversed ovals*.

51. *Will you describe the manner of forming the Direct Oval, and give an example?*

Begin at the top, and move downward with a left curve to form the left side, and upward with a right curve to form the right side.

EXAMPLE

52. *Describe the manner of forming the Reversed Oval, and give an example.*

Move upward with a left curve to form the left side, and downward with a right curve to form the right side.

EXAMPLE

Form 15

53. *What are Principles in writing?*
Principles are the constituent parts of letters.

54. *How many Principles are there according to the Spencerian System? Give examples of each.*
Seven Principles:

EXAMPLES

55. *Will you give descriptive names to the several Principles?*
The 1st is a *straight line*, the 2nd is a *right curve*, the 3rd is a *left curve*, the 4th is an *extended loop*, the 5th is a *direct oval*, or capital *O*, the 6th is a *reversed oval*, the 7th is the *capital stem*.
NOTE—Formerly Eight Principles were used, but for securing greater simplicity the present arrangement has been adopted.

56. *Which Principles are used in making the Small letters?*
The 1st, 2nd, 3rd, and 4th.

57. *Which Principles form the prominent parts of the Capitals?*
The 5th, 6th, and 7th. The others are combined with them in forming the minor parts of the capitals.

SMALL LETTERS

58. *What two forms has each letter of the alphabet?*
The small and capital form.

59. *Into how many classes are the small letters divided, and what are they?*
Three; short, semi-extended, and extended or looped.

60. *What are the heights of these three classes respectively?*
Short letters, one space; semi-extended, two spaces; extended or looped, three spaces.
NOTE—There are several exceptions to this rule to be noticed when the respective letters are more than a space in height?

61. *Will you name the thirteen Short Letters?*
They are:

62. *What two short letters are more than a space in height?*
The *r* and *s*, which are one-fourth space higher than the rest.

63. *Will you describe and form the First Principle?*
The First Principle is a straight line, usually on the main slant of 52°.

64. *Describe and form the Second Principle.*
The Second Principle is a right curve usually on the connective slant of 30°.

65. *Will you describe and form the Third Principle?*
The Third Principle is a left curve, usually on the connective slant of 30°.
NOTE—The principles are subject to various modifications in forming letters.

16 Theory *of* Spencerian Penmanship

66. *What do we call the Baseline or Base of a letter?*

The line, ruled or imaginary, upon which the letter rests.

NOTE—The horizontal line, ruled or imaginary, at the top of the short letters is sometimes called the *head line*; and that at the top of the capitals is called the *top line.*

67. *Will you please measure and analyze the small **i**?*

Height, one space; width, two spaces; distance between point and dot, one space. Analysis: Principles 2, 1, 2.

68. *Will you explain the construction of small **i**?*

Begin on baseline and ascend with a right curve, on connective slant, one space; here unite angularly and descend with a straight line on main slant to base; turn as short as possible without stopping the pen, and ascend with a right curve on connective slant, one space. Finish with a light dot, one space above the straight line on main slant.

NOTE—Directions are best remembered when immediately put in practice. The pupil should trace a model letter a number of times, repeating and following descriptions until the construction is familiar. During such drill the correct position ought to he observed. The exercise may he profitably varied, and easier movements secured by tracing and counting the strokes. Thus, in the small *i*: 1, 2, 1, dot.

69. *Will you measure and analyze small **u**?*

Height, one space; width, three spaces; distance between straight lines, one space. Analysis: Principles 2, 1, 2, 1, 2.

70. *Will you explain the construction of small **u**?*

First form the small *i*, as just described (but without dot), then repeat its two last lines. The lines unite in two equal angles at top, and two equal turns at base; the curves are similar and equidistant; the straight lines are parallel.

71. *Will you measure and analyze small **w**?*

Height, one space; whole width, three spaces; distance from straight line to dot, one-half space; and from dot to end of horizontal curve, one-half space.
Analysis: Principles, 2, 1, 2, 1, 2, 2.

72. *How should the small w be formed?*

Form like the small *u* to the completion of the second lower turn; thence ascend one space with a right curve to a point one-half space to right of the preceding line; make a light dot, and finish with a horizontal right curve carried one-half space to right.

73. *Will you measure and analyze small **n**?*

Height, one space; width, three spaces.
Analysis: Principles, 3, 1, 3, 1, 2.

74. *How should the small **n** be formed?*

Begin on baseline, and ascend with a left curve on connective slant, one space; turn short and descend with a straight line on main slant to base; then unite angularly and ascend with a left curve on connective slant, one space; again turn short and descend with a straight line on main slant to base; finally turn short and ascend with a right curve on connective slant, one space. Let the curves be equal, the turns equal, and the straight lines parallel.

75. *Will you please measure and analyze small* **m**?

Height, one space; width, four spaces.
Analysis: Principles, 3, 1, 3, 1, 3, 1, 2.

76. *How should the small* **m** *be formed?*

The *m* is formed precisely like the *n* with its first half repeated.

77. *Will you measure and analyze small* **v**?

Height, one space; whole width, two spaces; width from turn to dot one-half space, and from dot to end of horizontal curve, one-half space.

Analysis: Principles, 3, 1, 2, 2.

78. *How should the small* **v** *be formed?*

Form like the *n* to the point where it first returns to baseline; there turn short and finish with lines precisely like the last two in the *w*.

79. *Will you measure and analyze small* **x**?

Height, one space; whole width, two spaces; openings at top and base of letter, each one-third space.

Analysis: Principles, 3, 2, 3, 2.

80. *How should the small* **x** *be formed?*

Beginning on baseline ascend with left curve on connective slant, one space; turn short and descend with right curve, touching baseline three-quarters space to right of beginning; without lifting pen ascend to point even with first turn and one-third space to its right; descend with left curve to junction with right; thence diverging continue to baseline; turn short, and finish like *u*.

NOTE —Another method of making the *x*, preferred by some, is to *lift the pen* forming the first half, then put it down even with top turn, and one-third space to its right, and complete the letter as above described.

81. *Will you measure and analyze small* **o**?

Height, one space; whole width, one and one-half spaces ; width of oval, measured horizontally across middle, one-half space; distance from top to end of horizontal curve, one-half space.

Analysis: Principles, 3, 3, 2, 2.

82. *How should the small* **o** *be formed?*

Begin on baseline and ascend with a left curve on connective slant, one space; join angularly, and descend with a left curve on main slant to base; turn short, and ascend with an opposite right curve meeting the other at top; then carry out a slight horizontal right curve, as in *v* and *w* one-half space.

83. *Will you measure and analyze small* **a**?

Height, one space; width, three spaces; width of oval, one-half space.
Analysis: Principles, 3, 3, 2, 1, 2.

84. *How should the small* **a** *be formed?*

Begin on baseline, and ascend with a left curve one space, and two and one-half spaces to the right; retrace the curve one-quarter its length; then, separating, continue with left curve on main slant to baseline; turn short, and ascend with a slight right curve on connective slant to top; joining angularly, finish with lines precisely like the last two of the *i* or *u*.

85. *Will you measure and analyze small* **e**?

Height, one space; width of loop, one-fourth space, length of loop, two-thirds of a space; entire width of letter, two spaces.

Analysis: Principles, 2, 3, 2.

86. *How should the small* **e** *be formed?*

Begin on baseline and ascend with a right curve on connective slant, one space; turn short, and descend with a slight left curve on main slant, crossing the first curve at one-third its height, and continuing to baseline; turn short, and finish with a right curve, ascending on connective slant, one space.

87. *Will you measure and analyze the small* **c**?

Height, one space; length of top, one-third of a space; width of top, one-third space, measured at right angles to slant; entire width of letter, two spaces.

Analysis: Principles, 2, 1, 2, 3, 2.

88. *How should the small* **c** *be formed?*

Begin on baseline, and ascend by a right curve on connective slant, one space; unite angularly and descend with a straight line on main slant one-third of a space; make a very narrow turn, and ascend with a right curve on main slant one-third of a space; turning very short to left, and descending with a left curve, cross upward curve, continue to baseline and finish like the *e*.

89. *Will you measure and analyze small* **r**?

Main height, one and one-fourth spaces; whole width, two spaces; width from first curve to shoulder turn, measured horizontally, one-fourth space.

Analysis: Principles, 2, 3, 1, 2.

90. *How should the small* **r** *be formed?*

Begin on baseline and ascend with a right curve on connective slant one and one-quarter spaces; make a light dot, and descend with a slight left curve nearly vertical (5° to left of vertical), one-fourth of a space; turn short, and descend with a straight line on main slant to base; turn short again, and ascend with a right curve on connective slant, one space.

91. *Will you measure and analyze small* **s**?

Height, one and one-fourth spaces; width, measured horizontally at one-third of height, one-half of a space; height of dot above base, one-fourth space; entire width, two spaces.

Analysis: Principles, 2, 3, 2, 2.

92. *How should the small* **s** *be formed?*

Begin on baseline and ascend with a right curve the same as in *r*: unite angularly, and descend with slight left curve one-third space, and merging into a full right curve, continue to base: turn short and make a slight dot on first curve, one-quarter of a space above baseline; then retracing to base ascend with a finishing right curve on connective slant, one space.

93. *What four letters do we call Semi-extended?*

The

94. *Why are these letters called semi-extended?*

Because, as to length, they are between the *short letters* and the *extended letters*.

95. *What is the height of t, d and p above baseline?*

Two spaces.

96. *How far do the p and q drop below baseline?*

One and one-half spaces.

97. *Will you measure and analyze the small* **t***?*

Main height, two spaces; first curve joins descending straight line one space above base; entire width, two spaces; height of final curve, one space; distance of cross stroke below top, one-half space; length of cross stroke, one space.

Analysis: Principles, 2, 1, 2, 1.

98. *How should the small* **t** *be formed?*

Begin on baseline and ascend with a right curve on connective slant, one space, and continue with same curve on main slant, another space; at top unite squarely, and descend with a straight line on main slant, covering the curve one space, and continuing to baseline; turn short, and ascend by a right curve on connective slant one space. Finish with a horizontal straight stroke, crossing the main part one-half space below top, one-third being on the left, and two-thirds on the right.

99. *Will you measure and analyze small* **d***?*

Height of first part, one space; full height, two spaces; entire width, three spaces; opening between oval and straight line, one space.

Analysis: Principles, 3, 3, 2, 1, 2.

100. *How should small* **d** *be formed?*

Beginning upon baseline, form the first curve and pointed oval precisely as in *a*, omitting shade; without lifting the pen, the remainder of *d* is formed like the *t*, without crossing.

101. *Will you measure and analyze small* **p***?*

Length above baseline, two spaces; length below, one and one-half spaces; first curve unites with long straight line at top; height of finishing part, one space; entire width, three spaces.

Analysis: Principles, 2, 1, 3, 1, 2.

102. *How should small* **p** *be formed?*

Begin on baseline, and ascend with a right curve a little to the left of connective slant, two spaces; unite angularly and descend with a straight line on main slant, crossing the baseline one space from beginning point, and terminating squarely one and one-half spaces below; retrace lightly to baseline, and diverging finish precisely like the right half of the *n*.

103. *Will you measure and analyze small* **q***?*

Height above baseline, one space; length below, one and one-half spaces; entire width, three spaces; width of part below baseline, one-third space.

Analysis: Principles, 3, 3, 2, 1, 2, 3.

104. *How should small* **q** *be formed?*

 Begin on baseline and form a *pointed oval* as described in *a*; at top unite angularly, and descend with a straight line on main slant one and one-half spaces below the baseline; turn short, and ascend with a slight right curve on main slant to baseline, and finish with a left curve one space above, and one space to right of pointed oval.

105. *Will you measure the Fourth Principle, or extended loop?*

 Height, three spaces; horizontal width of loop one-half space; length from turn of loop to crossing, two spaces; width on baseline one space.

106. *How should the Fourth Principle or Loop be formed?*

 Begin on baseline, and ascend with a right curve three spaces; turn short, and descend with a slight left curve on main slant two spaces; then crossing first curve, continue with a straight line on main slant to base.

107. *Which are the Loop, or Extended Letters?*

The

108. *Which Principle is most prominent in the Extended Letters?*
The Fourth Principle, or Extended Loop.

109. *What is the length of the Looped or Extended Letters?*
Three spaces; except the *f* and long *s*, which are five spaces in length, extending three spaces above and two below baseline.

110. *Will you measure and analyze small* **h***?*

 Height, three spaces; width of loop measured horizontally, one-half space; crossing of loop, one space above base; entire width of letter, three spaces; height of finishing part, one space.

Analysis: Principles, 4, 3, 1, 2.

111. *How should small* **h** *be formed?*

 Beginning upon baseline form the *extended loop*, as just described; uniting angularly, make the remainder of the letter precisely like the right half of the *n*.

112. *Will you measure and analyze small* **k***?*

 Main height, three spaces; width of loop, one-half space; crossing of loop, one space above baseline; distance between the two straight lines, one-half space; between loop crossing and right end of small oval, one space; between second straight line and top of final curve, one space.

Analysis: Principles, 4, 3, 2, 1, 2.

113. *How should the small k be formed?*

Form the *Extended Loop* as described in *h*; then, uniting angularly, ascend with a left curve one and one-fourth spaces above base, and one space to the right of loop crossing; return leftward with a right curve one-half space to a point one space above baseline; unite angularly, and descend with a straight line on main slant to base; turn short and make final curve as in *u*.

114. *Will you measure and analyze small* **l***?*

Main height, three spaces; height of loop crossing above baseline, one space; height of final curve, one space; main width, two spaces; width of loop, one-half space.

115. *How should the small l be formed?*

Form *Loop* as described in *h*; turn short and finish as in *i* or *u*, with a right curve, ascending on connective slant one space.

116. *Will you measure and analyze small* **b***?*

Main height, three spaces; height of loop crossing above baseline, one space; entire width of letter, two spaces; width of *Loop*, one-half space; width from loop crossing to dot, one-half space; and from dot to end of final curve, one-half space.

Analysis: Principles 4, 2, 2.

117. *How should the small* **b** *be formed?*

Form *Loop* as described in *h*; turn short, and finish as described *w* and *v*.

118. *Will you measure and analyze small j?*

Height above baseline, one space; length below baseline, two spaces; main width, two spaces; width of loop, one-half space; height of dot above angle at top, one space.

Analysis: Principles 2, 4.

119. *How should the small* **j** *be formed?*

Begin on baseline and ascend with a right curve on connective slant, one space; unite angularly, and descend with a straight line on main slant, one space, and, changing to a gentle right curve, continue on same slant, two spaces below baseline; turn short, and ascend with a left curve, crossing at the baseline, and continuing above, on connective slant, one space. Finish with a light dot, as in *i*, one space above the straight line on main slant.

120. *Will you measure and analyze small* **y***?*

Height above baseline, one space; length below, two spaces; main width, three spaces; proportions of *Loop* same as *j*.

Analysis: Principles 3, 1, 2, 4.

121. *How should the small* **y** *be formed?*

Form the first half like the right of the *n*, *p*, or *h*; then, uniting angularly, finish with the Inverted Loop, as described in *j*. The *y* is precisely like the *h* inverted.

122. *Will you measure and analyze small* **g***?*

Height above baseline, one space; length below, two spaces; main width, three spaces; proportions of *pointed oval*, same as in *a*, *d* and *q*; proportions of loop, same as in *j*.

Analysis: Principles 3, 3, 2, 4.

123. *How should the small* **g** *be formed?*

Begin on baseline and form first left curve and *pointed oval* as in *a*, *d* and *q*; then unite angularly at top with an *Inverted Loop*, formed as in *j* and *y*.

124. *Will you measure and analyze small z?*

 Height above baseline, one space; length below, two spaces; whole width, two spaces; width of turn at baseline, one-fourth space; width of *Loop*, one-half space.
 Analysis: Principles 3, 1, 4.

125. *How should the small z be formed?*

 Form the first part like the left half of the *n*; uniting angularly at baseline, make a short upper turn (of same size as that at top of letter), returning to base one-fourth space to right; finish with *Inverted Loop* as in *j*, with straight line omitted, and ending one space to right of turn at top of letter.

126. *Will you measure and analyze small f?*

 Height above baseline, three spaces; length below baseline, two spaces; entire width of letter, two spaces; width of *Loops*, each one-half space.
 Analysis: Principles 4, 3, 2, 2.

127. *How should the small f be formed?*

First form the *Extended Loop* as in *h* and *k*: then from baseline, changing to a very slight left curve, continue downward upon main slant two spaces; turn short to the right and ascend with a right curve, crossing main line one-half space above baseline; here unite angularly, and finish with a right curve one space above baseline and one space to the right of the loop crossing.

128. *Will you measure and analyze long s?*

 Height above baseline, three spaces; length below two spaces; main width, two spaces; width of *Loops*, each one-half space.
 Analysis: Principles 4, 4.

129. *How should the long s be formed?*
Beginning upon baseline, make the *Extended Loop* as in *h* and *k*; then finish with the *Inverted Loop* and final curve as in *j* and *y*.

QUESTIONS FOR REVIEW

Will you assume and describe the position for writing? Will you describe the Combined Movement, and give an example of it? What two forms has each letter of the alphabet? How many of each form? What should be the main slant of letters? How many Principles are used in making the letters? Will you give their descriptive names? What is the unit for measuring the heights of letters? What is the unit for measuring their widths? How are the small letters classified in regard to length? Will you name the Short Letters in alphabetical order? Which of them are only one space in height, and which are more? Will you name the four Semi-extended Letters in alphabetical order? What is the length of these letters? Which of them drop below the baseline, and what is their length below? What Principles are used in making the Short and Semi-extended Letters? Will you name the Extended or Loop Letters in alphabetical order? Which extend only above the baseline? What is their height? Which extend both above and below the baseline? What are their respective heights above and lengths below the baseline? Which are the

longest of the small letters? Which Principle is most prominent in the Extended Loop Letters? Where do you always begin to form a small letter? Which letters are commenced with the right curve? Which letters are commenced with the left curve? At what height above the baseline are the small letters finished? Which letters finish with the right curve? Which finish with the left? In which small letters does the straight line appear, and how many times in each? Which letters have no straight line? Which is the widest of the small letters? Where do the right curves unite with the straight lines following in the *i*, *u* and *w*? Where do the left curves unite with the straight lines following in the *n* and *m*? At what point do the extended loops above the baseline cross? At what point do the extended loops below the baseline cross? What is the width of the extended loops? Will you give the main height and main width of each of the small letters in alphabetical order? Will you name the Principles in each of the small letters in alphabetical order?

CAPITAL LETTERS

130. *What is the height of the Capital Letters above the baseline?*
 Three spaces.

131. *What three capitals also drop below the baseline, and how far?*
 The J, Y and Z extend two spaces below the baseline.

132. *What class of small letters is of the same height as the capitals?*
 The Extended or Loop Letters.

133. *Into how many classes are the capitals divided, and what are they?*
 The capitals arc divided into three classes, according to the Principle (Fifth, Sixth or Seventh) most prominent in their formation.

134. *What is the Fifth Principle?*
 The Capital O or Direct Oval.

135. *Will you measure the Capital **O** or Fifth Principle?*

 Height, three spaces; width, two spaces, measured at right angles to main slant: distance between the two left curves, one-third space. The two sides of the O should curve equally.

136. *How is the Capital **O** formed?*

 Begin three spaces above the baseline, and descend with a full left curve, on main slant, to baseline; unite in an oval turn and ascend with an opposite right curve to within one-fourth space of top; unite in another oval turn and descend with another left curve within one-third space of the first and similar to it, ending one-third space above baseline.

137. *What is the Sixth Principle?*
 The Reversed Oval.

138. *Will you measure the Sixth Principle?*

Height, three spaces; main width, one and one-half spaces; width on baseline, one-third space.

139. *How should the Sixth Principle or Reversed Oval be formed?*

 Beginning upon the baseline, ascend with a full left curve, on main slant, three spaces; make an oval turn to right, and descend with a full right curve, touching the baseline one-third space to right of beginning.

140. *What is the Seventh Principle called?*

The Capital Stem.

141. *What are the proportions of the Capital Stem?*

 Main height, three spaces; height of base oval, one and one-half spaces; length of oval, two and one-half spaces; slant of oval, fifteen degrees from horizontal.

142. *How should the Capital Stem be formed?*

 Beginning three spaces above baseline, descend obliquely with a slight left curve one and one-half spaces; then changing to a right curve, form a *Reverse Oval*, on a slant of fifteen degrees, with its lower side touching baseline, and its upper curve rising one and one-half spaces above base, and finishing within one-third space (measured horizontally) of descending line, and one and one-fourth spaces above baseline.

143. *What four letters, from their general form, may be classed under the Fifth Principle or Capital* **O**?

The

144. *Will you measure and analyze Capital* **E**?

 Main height, three spaces; height of large oval, two spaces; width of same, one and one-half spaces; length of top, one-half length of base oval; width of top, one-half width of base oval; length of first curve, three-fourths space; length of the smallest loop, one-third space.

Analysis: Principles 3, 2, 3, 5.

145. *How should the Capital* **E** *be formed?*

 Begin three spaces above the baseline and descend with a left curve, on main slant, three-fourths of a space; turn short and ascend with an equal right curve, crossing first curve near top; unite in an oval turn, and descend with a left curve, on main slant, one and one-fifth spaces; unite in a small loop, at right angles to main slant, with a Capital O, resting upon baseline, and with its terminal point one-third space above it.

146. *Will you measure and analyze Capital* **D**?

 Main height, three spaces; main width, two spaces; height of stem, two and one-half spaces; distance from stem to final curve, one-third space; height of small loop, three-fourths space; distance between loop and lowest point of oval on baseline, two spaces.

Analysis: Principles 3, 2, 3, 2, 3, 2, 3.

147. *How is the Capital* **D** *formed?*

 Begin two and one-half spaces above, and descend with left-and-right curve, on main slant, to baseline; turn short to left, and ascend with a slight left curve three-fourths space, crossing stem; unite, and descend obliquely with a slight right-and-left curve, touching baseline two spaces to right of loop; unite in an oval turn, and ascend with a

right oval curve, on main slant, three spaces; make another oval turn to left, and descend with an opposite left curve, on main slant, within one-third space of stem, and terminating one-third space above baseline.

148. *Will you measure and analyze Capital* **C**?

Height, three spaces; length of first oval, two spaces; width of same and spaces to right and left, each three-fourths space.
Analysis: Principles 3, 2, 3, 2.

149. *How is the Capital* **C** *formed?*

Begin two and three-fourths spaces above baseline, and descend with a left curve on main slant, two spaces; make oval turn to right, and ascend with opposite right curve, crossing the first near top and continuing to full height of letter; unite in an oval turn, and descend with a full left oval curve, on main slant, to baseline; making another broad oval turn, ascend with a right curve, on connective slant, one space.

150. *In which capitals is the Sixth Principle or Reversed Oval most prominent?*

In the

151. *Will you measure and analyze Capital* **X**?

Main height, three spaces; main width of *Reversed Oval*, one and one-half spaces; width of oval upon baseline, one-third space; distance between parts of X at top, one and two-thirds spaces; at base, one and one- third spaces; point of contact between main parts of letter, one and two-thirds spaces above base.
Analysis: Principles 6, 3, 2.

152. *How should the Capital* **X** *be formed?*

First form the *Reversed Oval* or Sixth Principle as above described; then from a point even with the top, and one and two-thirds spaces to the right, descend with a left curve on main slant, touching *Reversed Oval*, one and one-third spaces down, and, thence continuing, touch baseline one and one-third spaces to the right of *Oval*; turn rather short, and finish with a right curve one space high and one space to the right of preceding line.

153. *Will you measure and analyze Capital* **W**?

Main height, three spaces; main width of *Oval*, one and one-half spaces; distance between top of *Oval* and the angle to its right, one and two-thirds spaces; distance on baseline between angular joinings, one and two-thirds spaces; distance between last two curves, one space; height of final curve, two spaces; distances at middle height between four curves upon right of letter, equal.
Analysis: Principles 6, 2, 3, 3.

154. *How is the Capital* **W** *formed?*

Form the *Reversed Oval* as before described; then unite angularly on baseline, and ascend with a slight right curve to a point even with top of *Oval* and one and two-thirds spaces to its right; unite angularly, and descend by a very slight left curve touching base one and two-thirds spaces to right of *Oval*; again unite angularly, and ascend with a left curve, ending two spaces above base and one space to the right of preceding line.

155. *Will you measure and analyze Capital* **Q***?*

 Main height, three spaces; width of *Oval* one, and one-half spaces; length of small loop, one space; height of same, one-fourth space; height of final curve, one space; distance between end of final curve and the *Reversed Oval*, one space.

Analysis: Principles 6, 3, 2.

156. *How is the Capital* **Q** *formed?*

 Make *Reversed Oval* as in X to middle point of its right side; thence sweep more rapidly to the left, cross left curve close to baseline, and, continuing horizontally, one space to left of beginning point of letter; turn short, and carry over a horizontal left curve, completing loop, and touching base two-thirds space to right of loop crossing, ascend with a right curve on connective slant one space.

157. *Will you measure and analyze Capital* **Z***?*

 Proportions of *Reversed Oval* same as in X; length of *Loop* below baseline, two spaces; width of same, one-half space, full; height of small loop, one-half space; distance from base of small loop to crossing of larger one, one space; final curve ends one space above baseline, and one space to right of *Reversed Oval*.

Analysis: Principles 6, 3, 2, 4.

158. *How is the Capital* **Z** *formed?*

 Form *Reversed Oval* as in X and W; then turn short on baseline, and ascend with a left curve, forming a loop one-half space in height, and one-fourth of a space in width; unite in oval turn, and descend with a right curve, touching baseline one space to right of small loop, and continuing, finish with an *Extended Loop* like that in small z, but somewhat fuller.

159. *Will you measure and analyze Capital* **V***?*

 Main height, three spaces; width of *Oval*, one and one-third spaces; width between beginning curve and short turn on line, two-thirds of a space; width between final curve and straight line at middle height, one-half space; width between top of final curve and *Oval*, one space.

Analysis: Principles 6, 2, 3.

160. *How is the Capital* **V** *formed?*

 Make *Reversed Oval* as in X to termination of upper third of right side; thence descend on main slant with straight line, touching base two-thirds space to right of beginning; turn short, and ascend with right and left curve two spaces, terminating one space to right of *Oval*.

161. *Will you measure and analyze Capital* **U***?*

 Main height, three spaces; width of *Oval*, one and one-third spaces; distance on baseline, from beginning point to first turn, two-thirds of a space; height of right portion, two spaces; distance between straight lines, one space; opening between second straight line and final curve, one space.

Analysis: Principles 6, 2, 1, 2.

162. *How is the Capital U formed?*

 Form oval part the same as described for V; then turn short on baseline, and ascend with a right curve two spaces to a point, one space to the right of *Oval*; unite angularly, and descend with a straight line, on main slant, to base; turn short, and ascend with a right curve one space, terminating one space to the right of preceding line.

163. *Will you measure and analyze Capital Y?*

 Height above baseline, three spaces; length below baseline, two spaces; proportions of *Reversed Oval*, same as in the V and U; height of right portion above base, two spaces; width of *Loop*, one-half space, full; width between straight lines, one space; distance between second straight line and end of final curve, one space.

Analysis: Principles 6, 2, 1, 4.

164. *How is the Capital Y formed?*

 Form the main part the same as the U to point where second straight line approaches base; thence, continuing downward, finish with *Inverted Loop* like that in small *y*, but a trifle fuller.

165. *Will you measure and analyze Capital I?*

 Main height, three spaces; height of base oval, one and one-half spaces; width of loop forming top, one space; crossing of loop, one-third space above base.

Analysis: Principles 6, 7.

166. *How is the Capital I formed?*

 Beginning on baseline, ascend with a left curve, on main slant, three spaces; turn short, and descend with an opposite right curve, crossing the first one-third space above base, and touching baseline one space to left of beginning point; finish by completing base oval as in *Capital Stem*, ending in middle of loop.

167. *Will you measure and analyze Capital J?*

Height above baseline, three spaces; length below, two spaces; width of upper loop, one space; width of lower loop, one-half space, full; crossing of loops, one-third space above base.

Analysis: Principles 6, 2, 3.

168. *How is the Capital J formed?*

Beginning on baseline, ascend with left curve three spaces; turn short, and descend with right curve on main slant, crossing first curve one-third space above baseline, and continuing two spaces below it; turn short, and ascend with left curve, crossing right curve one-third space above base, and terminate one space above baseline and one space to right of upper loop, or oval.

169. *In what capitals does the Seventh Principle or Capital Stem chiefly appear?*

In the

170. *Will you measure and analyze Capital* **A***?*

Main height, three spaces; height of oval, one and one-half spaces; length of oval, two and one-half spaces; distance between parts of letter on baseline, one and two-thirds spaces.

Analysis: Principles 7, 3, 3, 2.

171. *How is the Capital* **A** *formed?*

First form the *Capital Stem*, as previously described; then from top of stem draw down a slight left curve touching base one and two-thirds spaces to right *Stem*; from a point on the last curve, one and one-fourth spaces above base, descend with a left curve, three-fourths space, and, crossing, finish with a right curve, one space above base, and one space to the right. The cross passes to the middle of opening between stem and long left curve.

172. *Will you measure and analyze Capital* **N***?*

Main height, three spaces; proportions of *Stem* and distance between left curve and *Stem* at base, same as in A; height of last curve, two spaces; distance between top of last curve and the preceding line, one space.

Analysis: Principles 7, 3, 3.

173. *How should the Capital* **N** *be formed?*

Form like Capital A to the point where long left curve touches baseline; there turn short, and ascend with a left curve, two spaces, finishing one space to right of preceding curve.

174. *Will you measure and analyze capital* **M***?*

Main height, three spaces; proportions of *Stem*, same as in A and N; distance between the two angles at top and the two short turns at base, each one space; distance between lowest point of *Stem* and first turn to right, one and two-thirds spaces; distance between four long strokes at middle height, each one-third space ; distance between two last curves, one space.

Analysis: Principles 7, 3, 3, 3, 2.

175. *How should the Capital* **M** *be formed?*

Form like the N to second point of contact with baseline; turn short, and ascend with a left curve to a point even with top of stem and one space to its right; unite angularly, and descend with another left curve, touching baseline one space to right of preceding turn; then turn short, and finish with a right curve, one space high and one space to the right of last curve.

176. *Will you measure and analyze Capital* **T***?*

Main height, including the cap, three spaces; height of *Stem*, two and one-half spaces: proportions of base oval, same as in A, N, and M; distance (measured at right angles to main slant) between beginning point of cap, and the *Capital Stem*, one space; cap terminates two spaces to right of *Stem*; width of small loop and spaces to its right and left, each one-third space.

Analysis: Principles 7, 3, 2, 3, 2.

177. *How is the Capital* **T** *formed?*

Begin the *Capital Stem* two and one-half spaces above base, making its first curve a little fuller than in A, N, and M, but forming the oval as in those letters. Begin cap two spaces from base and one space to left *Stem*; ascend with left curve on main slant one space; turn short and descend on main slant with right curve one space; turn short and ascend with another left curve crossing right near top, and continuing to full height of letter directly over top of *Stem*, then merge into horizontal right curve terminating two spaces to right of *Stem*.

178. *Will you measure and analyze Capital* **F**?

Proportions of cap, and also of *Stem* to highest point of base oval, precisely the same as in the T; top of characteristic mark, one and one-half spaces above base; length of same, one-fourth space.

Analysis: Principles, 7, 3, 3, 2, 3, 2.

179. *How is the Capital* **F** *formed?*

Form the F just the same as the T, except the finish of the *Stem*; which merges into a right curve, crosses first curve of stem one-third space, and at half height of letter unites angularly with a slight left curve, called the characteristic, drawn downward upon main slant, one- fourth space.

180. *Will you measure and analyze Capital* **H**?

Height of right side, three spaces; height of left side, two and one-half spaces; distance between the sides, at top, two spaces; at base, one and two-third spaces; the oval of same proportions as in A, N, and M; the cross begins one and one-fourth spaces above base.

Analysis: Principles, 2, 7, 3, 3, 2.

181. *How is the Capital* **H** *formed?*

Beginning on baseline, ascend with right curve two and one-half spaces; unite angularly with *Capital Stem*, resting upon baseline, and with oval of same form size and slant as in A, N, and M, and divided a little below its middle by right curve. From a point three spaces above base and two spaces to right of *Stem*, descend with left curve (nearly straight at its lower end), touching baseline one and two-third spaces to right of oval. Form the finish as in the A, letting it pass to the middle of the space between the right and left sides of the letter.

182. *Will you measure and analyze Capital* **K**?

Height of right side, three spaces; height of left side, two and one-half spaces; distance between the sides, at top, two spaces; at base, one and two-third spaces; height of small loop above base, one and one-half spaces; width of opening between final and its preceding curve, one space.

Analysis: Principles, 2, 7, 3, 2, 2, 3, 2.

183. *How is the Capital* **K** *formed?*

Form the left side as in H; then from a point one-half space above and two spaces to right of *Stem*, descend obliquely with left and right curve, one and one-half spaces; form a small loop about *Stem*, at right angles to main slant, and descend with slight right and left curve, touching baseline, one and two-third spaces to right of *Stem*; turn short, and finish with right curve, one space in height and one space to right of preceding line.

184. *Will you measure and analyze Capital* **S**?

Main height, three spaces; width of loop, measured horizontally, one-half space; length of loop, one and one-half spaces; length of base oval, two and one-half spaces; height of oval, one and one-half spaces.

Analysis: Principles, 2, 7.

185. *How is the Capital* **S** *formed?*

Begin at base and ascend with a right curve, three spaces; turn short, and descend with a full left curve, one and one-half spaces, completing loop; here cross the first curve and complete the letter with the capital stem oval, touching baseline, one and one-half spaces to right of beginning point of letter, crossing first curve three-fourths space from its beginning, rising to half height of letter, and terminating upon first curve, one and one-fourth spaces above base. The base oval is divided a little below its middle by first curve.

186. *Will you measure and analyze Capital* **L**?

Main height, three spaces; width of upper loop, measured horizon tally, one-half space; length of same, one and one-half spaces; length of small loop, one space; length of small loop on the left of first curve, one-fourth space; width of small loop, one-fourth space.

Analysis: Principles, 2, 7, 3, 2.

187. *How is the Capital* **L** *formed?*

Form the L like the S to the point where the *Stem* recrosses first curve; thence continuing one- fourth space leftward, turn short and carry back a horizontal left curve, completing loop, one space long and one-fourth wide; continuing, touch baseline one-half space to right of loop crossing, and ascend with a right curve on connective slant, one space.

188. *Will you measure and analyze Capital* **G**?

Main height, three spaces; width of loop, one-half space; length of loop, two spaces; distance from right side of loop to top of *Stem*, three-fourths space; height of *Stem*, one and one-half spaces; distance between end of oval and end of beginning curve, one space; length of oval, two and one-half spaces; height of oval, one and one-half spaces.

Analysis: Principles, 2, 3, 2, 7.

189. *How is the Capital* **G** *formed?*

Ascend with a right curve as in S and L; then turn short and descend with left curve, crossing right, one space above base; turn with left curve, descending one-fifth space, and then ascend will a right curve to half height of letter and three-quarters space to right of loop; unite angularly and finish with the capital stem oval. This oval touches baseline two spaces to right of beginning point of letter, crosses first curve one space from its beginning, rises to half height of letter, and ends midway between loop and *Stem*.

190. *Will you measure and analyze Capital* **P**?

Full height, three spaces; height of *Stem*, two and one-half spaces; width of letter at mid-height, one and one-half spaces, measured at right angles to slant; distance between *Stem* and right curve, one-half space; final curve recrosses *Stem* at mid-height of letter.

Analysis: Principles, 7, 3, 2.

191. *How is the Capital* **P** *formed?*

Begin two and one-half spaces above, and descend by a left and right curve on main slant to baseline; then in an oval turn unite with and ascend by a left curve on main slant, three spaces; here make another oval turn and descend with a right curve, crossing *Stem* one-half space from its top, and, recrossing it, terminate one-fourth space to left of *Stem* at mid-height of letter.

192. *Will you measure and analyze Capital* **B**?

Height of letter, three spaces; height of *Stem*, two and one-half spaces; distance between *Stem* and right curves near top and bottom, each one-half space; final curve drops below baseline, one-fifth space; height of small loop, one and one-half spaces; length of same, one-third space.

Analysis: Principles, 7, 3, 2, 2, 3.

193. *How is the Capital* **B** *formed?*

Form like the Capital P to the point where right curve recrosses *Stem* at mid-height of letter; here unite in narrow loop (crossing stem at right angles to main slant), with a right curve descending on main slant one-half space to right of *Stem* and one-fifth space below baseline; in an oval turn unite and ascend with left curve passing through middle of oval and finishing within one-third space of *Stem*.

194. *Will you measure and analyze Capital* **R**?

The measurements are the same as in the B, except for the two last curves. Distance between turns upon baseline, one and one-half spaces; height of final curve, one space; distance between same and the preceding curve, one space.

Analysis: Principles, 7, 3, 2, 2, 3, 2.

195. *How is the Capital* **R** *formed?*

Form like Capital B to completion of small loop; thence descend with a slight right and left curve, touching base one and one-half spaces to right of *Stem*, turn short and finish with a right curve, ascending one space, and ending one space to right of preceding line.

NOTE —It will be observed that the finish of the R from the beginning of small loop is precisely like the finish of K.

QUESTIONS FOR REVIEW

Will you make and name the prominent Principles used in the Capital Letters? Will you make the Capital Letters, according to the Spencerian System, in alphabetical order? What is the main height of Capitals above the baseline? Which Capitals extend below the baseline? What is their length below? Will you name, in alphabetical order, the Capitals that contain the Fifth Principle, or Direct Oval? Will you name, in alphabetical order, the Capitals that contain the Sixth Principle, or Reversed Oval? Will you name, in alphabetical order, the Capitals that contain the Seventh Principle, or Capital Stem? Will you give the exact proportions of each of the Capitals in alphabetical order? Which do you find the most difficult Capital to form?

Spacing

196. *How do you move in spacing and combining small letters in writing words?*

The hand slides on the nails of the third and fourth fingers, and is assisted by the first and second fingers and thumb in shaping and joining the lines.

197. *What is the rule for spacing and combining small letters in words?*

In spacing and joining letters in words, carry the connecting curve one and one-fourth spaces to the right of preceding letter.

EXAMPLE

198. *Which letters cannot be joined according to this rule?*

The a, d, g and q, which require the connecting curve to be carried two spaces to the right of the preceding letter in order to join to their right side.

EXAMPLE

199. *When a word begins with a Capital Letter which does not join to small letters, what is the rule for spacing?*

The first curve of the first small letter should begin within one-fourth of a space of the capital.

EXAMPLE

200. *What is the general rule for spacing between words composed entirely of small letters?*

The first curve of a word should begin on baseline one and one-half spaces to the right of the final downward stroke of the preceding word.

EXAMPLE

NOTE—This rule causes the beginning point of a word to fall practically in a vertical line under the final point of the preceding word.

201. *What is the rule for spacing between sentences?*

The spaces between sentences should be twice as great as between words.

Remark—Regular, uniform spacing depends chiefly upon a good position and regular, uniform movement. When the latter are secured, the former will not be difficult to attain. Exercises like numbers 8 and 10 in the Movement Exercises graphic (page 8) are specially recommended for efficient drill in spacing.

Shading

202. *Will you examine your pen and describe it?*

The pen is a pointed instrument for writing with ink. It is made of steel (or gold), and is attached to a convenient handle by a clasp; its nib is split through the middle, and the two parts are called the teeth. The two teeth are alike; they are thin and sharp, and, in a good pen, meet so as to form a fine smooth point.

203. *How do you make light strokes?*

By moving the pen lightly on the paper without springing or spreading the teeth.

204. *Will you take the correct position and use your pen (without ink) as in making shaded strokes, and then describe the manner of producing them?*

EXAMPLES ₁ / ₂ / ₃ / ₄ / ₅ / TO BE TRACED.

Shades are made by springing the pen by a pressure to spread the teeth, then lightening the pressure, and allowing them to return to place.

205. *How many different forms of shaded strokes are there in writing?*

Five.

206. *Which five letters will illustrate the five forms of shaded strokes?*

The ₁ *t* ₂ *p* ₃ *l* ₄ *y* ₅ *O*

207. *Will you describe the first shade, and name all the letters in which it appears?*

The *t* is shaded by pressing at top squarely on the teeth of the pen, and gradually lightening it in descending to baseline. The *d* is shaded in the same manner.

EXAMPLES *t d*

NOTE —The medium shade upon the *t* and *d* terminates one-half space above base.

208. *Will you describe the second shade, and name all the letters in which it appears? The shade of p is made by beginning with a slight pressure at baseline or middle of stroke, increasing gradually and stopping squarely at lower end. There is a style of small t, called "final" t, sometimes used, which has the same form of shade.*

EXAMPLES *t p*

209. *Will you describe the third form of shade, and name all the letters in which it appears?*

The shade of *l* is made by increasing pressure on the pen gradually in descending, and lightening up for the turn. This form of shade occurs in the following letters:

b f l

210. *Will you describe the fourth form of shade, and name the letters in which it appears?*

The shade of *y* is made by pressing evenly on the pen in descending on the straight line between the turns. This form of shade appears in the following letters:

h k y V U Y

211. *Will you describe the fifth form of shade, and name the letters in which it appears?*

The shade on the oval, and on all curved lines, is made by increasing the pressure toward middle of curve, and then gradually diminishing it.

This shade occurs in the three small letters, *a*, *g* and *q*, and in all the capitals except the V, U, and Y.

212. *What is the rule where a shaded letter is doubled?*

The second should receive only a half shade.

Remark—The proper shading of any letter may be readily acquired by first tracing a model form with dry pen, naming the light and shaded strokes as they occur. Thus in Capital C: light, light, shade, light. Another method is to count the strokes, and emphasize the number indicating the shaded stroke. Thus, in small *d*, count, one, two, three, *four*, one.

Figures

Remarks—The forming of good figures is of much practical importance. Figures show results: they should never lie or be doubtful. Let the distinctive character of each be as carefully learned as the forms of letters, and at all times be accurately observed. Cultivate the habit of making your figures so plain and perfect as to preclude the possibility of mistaking one for another.

213. *How many numeral characters, or figures are there?*

Ten.

214. *How are the figures measured?*

In the same manner as letters. The *unit space* for measuring their heights is the *height of small i*; for measuring their *widths*, the distance between the straight marks in *small u*.

215. *What is the height of the figures in the medium handwriting?*

One and a half spaces; except the *6* which extends one-half space above, and the *7* and *9* which continue one-half space below the other figures.

216. *What is the width of the figures?*

One space, measured horizontally at widest part, except the *1* and the *0*.

NOTE—In this rule, the width of the 2 is considered without final curve, and the width of 4 without horizontal curve.

217. *Will you measure and analyze the Cipher?*

Height, one and one-half spaces; width, measured at right angles to slant, one-half space.

Analysis: Principles, 3, 2.

218. *How is the Cipher formed?*

Begin one and one-half spaces above baseline and descend with a slight left curve on main slant, to base; turn short and ascend with an opposite right curve, meeting first curve at top.

219. *Will you measure and analyze the figure 1?*

Height, one and one-half spaces.

Analysis: Principle, 1.

220. *How is the figure 1 formed?*

Commence one and one-half spaces above, and descend with a straight line on main slant to baseline, making lower part a little heavier than top.

221. *Will you measure and analyze the figure 2?*

Main height, one and one-half spaces; loop at top descends one-half height of figure; height of final curve, one-third space.

Analysis: Principles, 2, 3, 2, 3, 2.

222. *How is the figure 2 formed?*

Begin one and one-half spaces above, and descend by a right curve on main slant half way to baseline; turn short and ascend by an opposite left curve to full height of figure, crossing first curve and forming loop; in a turn unite with, and descend by a right curve to baseline; turn short and return with a horizontal left curve, completing small loop; descend to baseline, and finish with a right curve, ascending one-third of a space.

223. *Will you measure and analyze the figure 3?*

Main height, one and one-half spaces; height of small loop, one space; base oval ends at one-half height of figure; loop at top descends one-quarter height of figure.

Analysis: Principles, 2, 3, 2, 2, 3.

224. *How is the figure 3 formed?*

Begin one and one-half spaces above baseline, and descend with a right curve on main slant, one-fourth way to baseline; turn short and ascend with left curve to full height of figure, crossing first curve and completing loop; then, in a short turn unite with and descend by a right curve, one-half space; in a narrow loop unite with a base oval like that of the *Capital Stem*, resting upon baseline and terminating at half height of figure, just under the small loop.

225. *Will you measure and analyze the figure 4?*

Main height, one and one-half spaces; length of left side, one space.

Analysis: Principles, 2, 3, 3.

226. *How is the figure 4 formed?*

Begin one and one-fourth spaces above baseline, and descend on main slant with a slight left curve, one space; then, in a sharp angle, unite with a horizontal left curve, one and one-half spaces in length; from a point at full height of figure, and one space to right of first curve, draw down a slight left curve upon main slant, crossing middle of horizontal curve, and terminating upon baseline.

227. *Will you measure and analyze the figure 5?*

Main height, one and one-half spaces; proportions of small loop and base oval, same as in the figure 3; height of small loop above base, one space; length of straight line, two-thirds of a space.

Analysis: Principles, 2, 2, 3, 1.

228. *How is the figure 5 formed?*

Begin one and one-half spaces above baseline, and descend on main slant with a slight right curve, one-half space; continuing, form small loop and base oval as in the figure 3; finish with horizontal straight line drawn from top of figure two-thirds space to right.

229. *Will you measure and analyze the figure 6?*

Main height, two spaces; height of oval, one space; distance between left curves, one-third width of figure.

Analysis: Principles, 3, 2, 3.

230. *How is the figure 6 formed?*

Begin two spaces above baseline, and descend by a slight left curve on main slant to base; then, in a full turn, unite with and ascend by a right curve on main slant, one space; make a short turn to left, and finish with a left curve descending near first stroke upon main slant to base.

231. *Will you measure and analyze the figure 7?*

Height above baseline, one and one- half spaces; length below baseline, one-half space.

Analysis: Principles, 1, 3, 2, 1.

232. *How should the figure 7 be made?*

Begin one and one-half spaces above baseline, and descend one- fourth space with a straight line upon main slant; unite angularly, and carry to the right a left and right curve, one space, and at full height of figure unite in another angle, with a straight line descending upon main slant, and terminating one-half space below baseline.

233. *Will you measure and analyze the figure 8?*

Main height, one and one-half spaces; height of beginning point above base, one space; loop crossing, at about one-half height of figure.

Analysis: Principles, 2, 3, 2, 3.

234. *How is the figure 8 formed?*

Begin one space above baseline, and ascend by a right curve, one-half space; then in an oval turn, unite with a full left curve, descending half way to base; there, merging into right curve, continue to baseline; turn short and ascend with a left curve, completing loop at middle height, and extending through middle of top to full height of figure.

235. *Will you measure and analyze the figure 9?*

Height above baseline, one and one-half spaces; length below baseline, one-half space; *pointed oval* descends one space to middle height of figure, and is of the same size and form as in *a, d, g* and *q*.

Analysis: Principles, 3, 2, 1.

236. *Will you describe the manner of forming the figure 9?*

Begin one and one-half spaces above baseline, and form *pointed oval* as in the small letters *a, d, g* and *q*; at top, unite angularly with straight line drawn downward upon main slant to one-half space below baseline.

NOTE —When figures are shaded, the same kinds of shaded strokes are used as in shading letters.

The *First Principle* (#63, page 16) is a straight line, slanting to the right of the perpendicular, forming an angle of 52°, with the horizontal line.

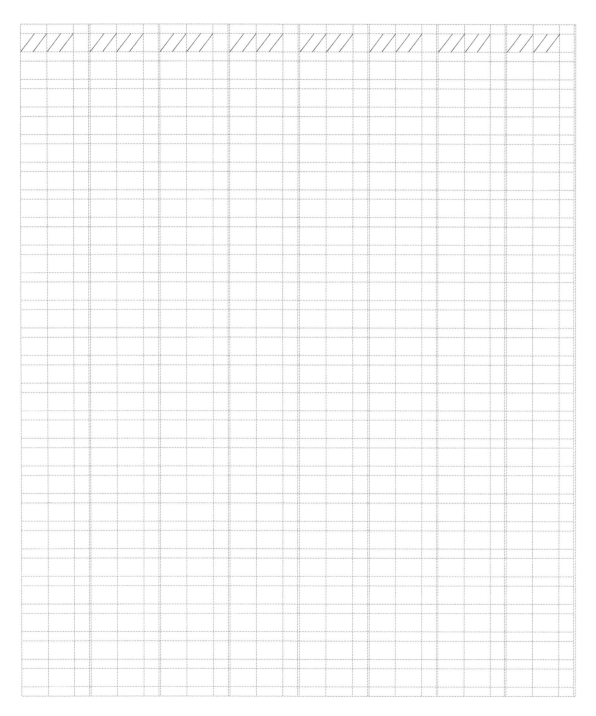

The *Second Principle* (#64, page 16) is a right curve so called because it appears in the right side of an oval figure. The *Third Principle* (#65, page 16) is the left curve, so called because it appears in the left side of an oval figure. Unless otherwise specified, right and left curves are on the connective slant of 30°.

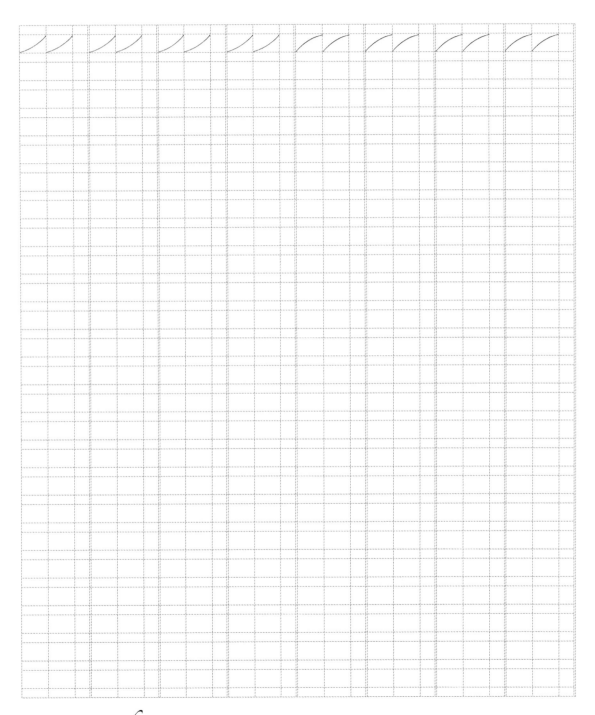

Theory *of* Spencerian Penmanship

Practice the Short Letters (pages 41 to 53), which all begin on the baseline and extend one space in height.

Small letter i (#68, page 17): ascending right curve; angular joining; descending straight line; very short turn to the right; ascending right curve; small dot one space above slanting straight line. Analysis of principles: 2, 1, 2, dot.

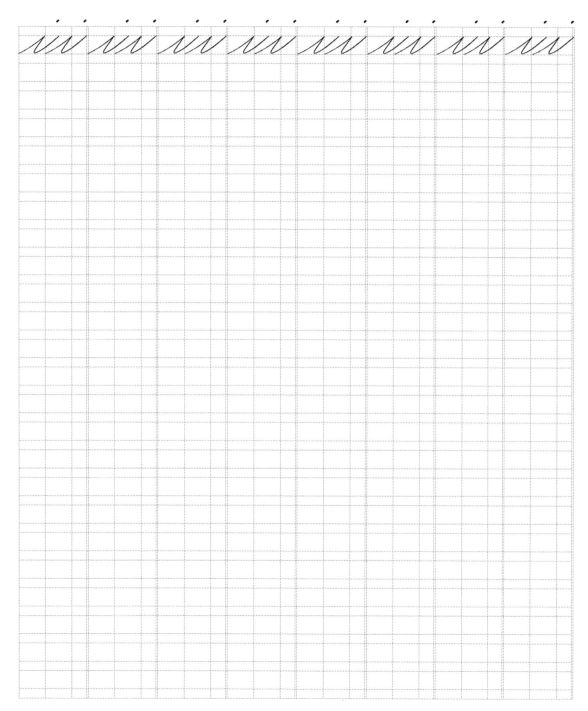

Small letter u (#70, page 17): ascending right curve; angular joining; descending straight line; short right turn; ascending right curve; angular joining; descending straight line; short right turn; ascending right curve. This is the same base used in *small letter i*; for *u* it is repeated and no dots are added. Analysis of principles: 2, 1, 2, 1, 2.

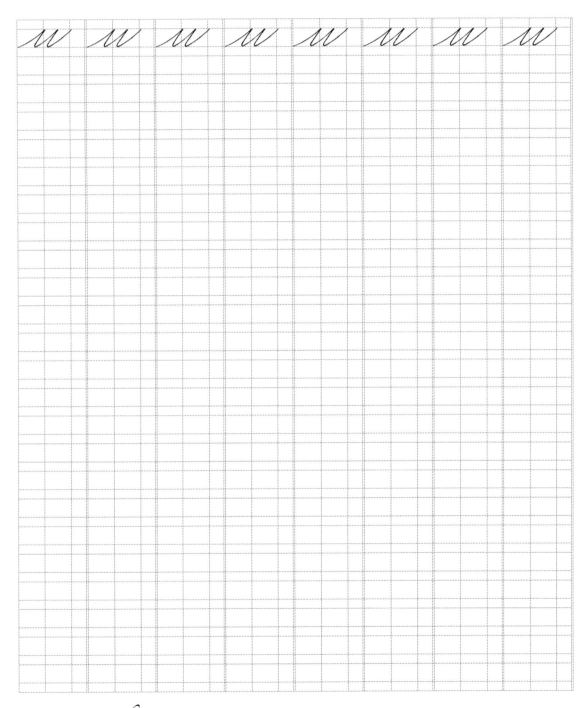

Small letter w (#72, page 17): ascending right curve; angular joining; descending straight line; short right turn; ascending right curve; angular joining; descending straight line; short right turn; ascending right curve on steeper main slant; light dot; one-half space horizontal right curve. This letter commences with the same first four lines as those used for *small letter u*. Analysis of principles: 2, 1, 2, 1, 2, 2.

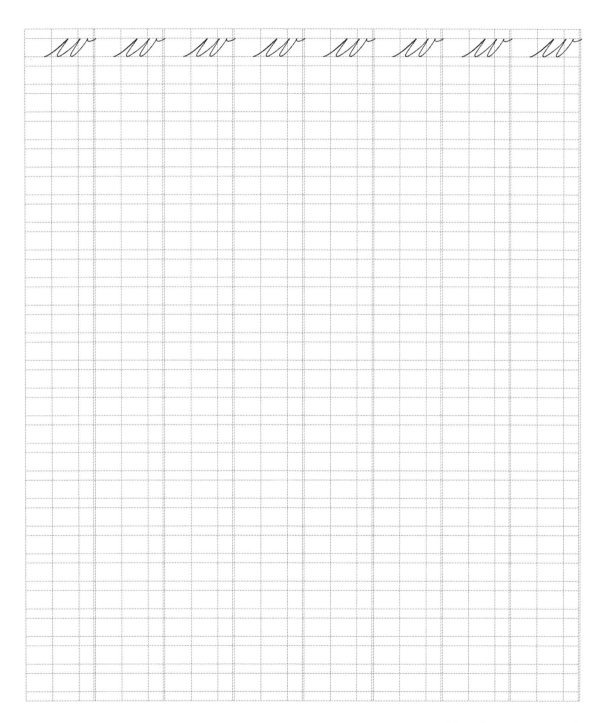

Small letter n (#74, page 17): ascending left curve; short right turn; descending straight line; angular joining; ascending left curve; short right turn; descending straight line; short right turn; ascending right curve. Analysis of principles: 3, 1, 3, 1, 2.

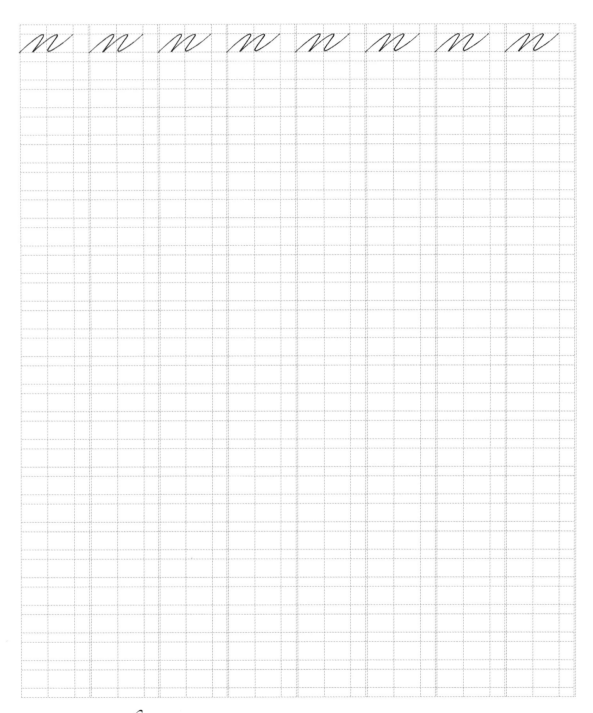

Small letter m (#76, page 18): steeper ascending left curve; short right turn; descending straight line; angular joining; ascending left curve; short right turn; descending straight line; angular joining; ascending left curve; short right turn; descending straight line; short right turn; ascending right curve. This letter is exactly like the *small letter n*, with one additional arch created by an extra left curve and straight line. Analysis of principles: 3, 1, 3, 1, 3, 1, 2.

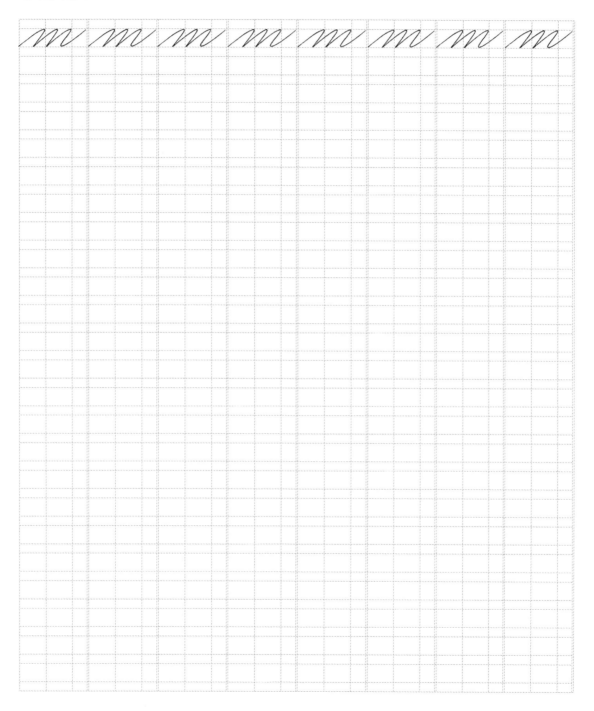

Small letter v (#78, page 18): ascending left curve; short right turn; descending straight line; short right turn; ascending right curve on steeper main slant; light dot; one-half space horizontal right curve. This letter commences with the first two lines of *small letter n* and is completed by the final two lines of *small letter w*. Analysis of principles: 3, 1, 2, 2.

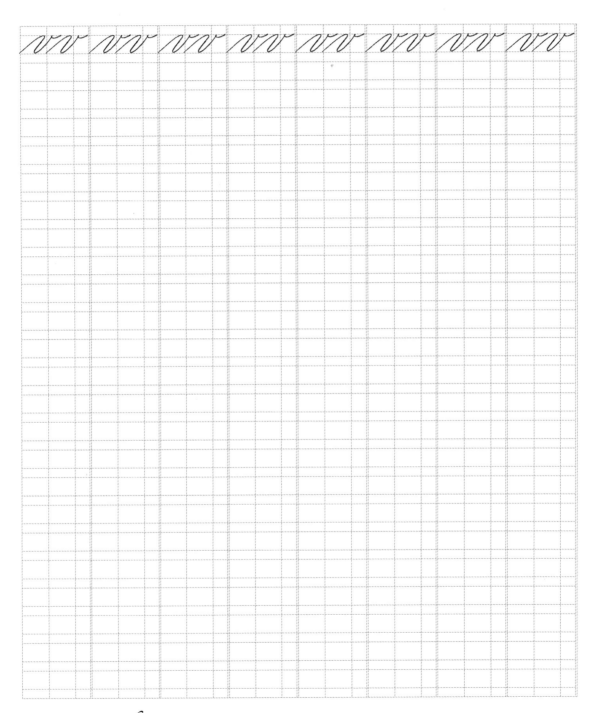

Small letter x (#80, page 18): ascending left curve; short right turn; descending right curve touching baseline three-quarters space to right of start; without lifting pen ascend with straight line on connective slant to point as high as first turn and one-third space to its right; retrace this line back to where it meets original descending right curve; continue to baseline with descending left curve on main slant; short right turn; ascending right curve. Analysis of principles: 3, 2, 3, 2.

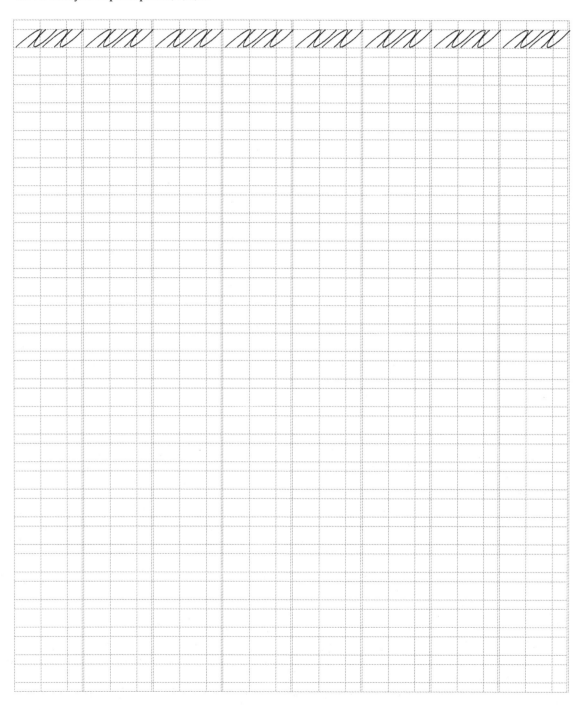

Small letter o (#82, page 18): ascending left curve; angular joining; descending left curve on steeper main slant; short right turn; ascending right curve exact mirror of previous left curve, creating pointed direct oval one-half space wide; one-half space horizontal right curve as in *small letters w* and *v*. Analysis of principles: 3, 3, 2, 2.

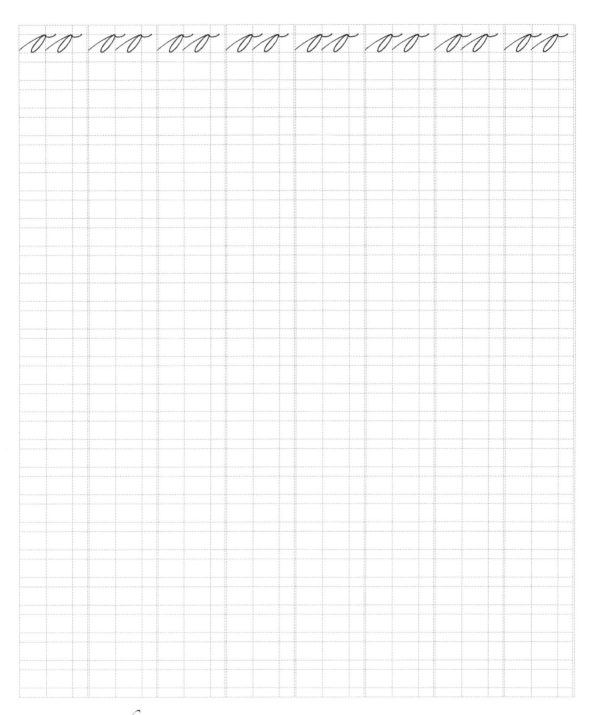

Small letter a (#84, page 18): ascending left curve; descending left curve retracing first curve one-quarter space before separating and continuing on steeper main slant; short right turn; ascending right curve exact mirror of previous left curve, creating pointed direct oval one and one-half spaces wide; angular joining; descending straight line; very short right turn; ascending right curve. Analysis of principles: 3, 3, 2, 1, 2.

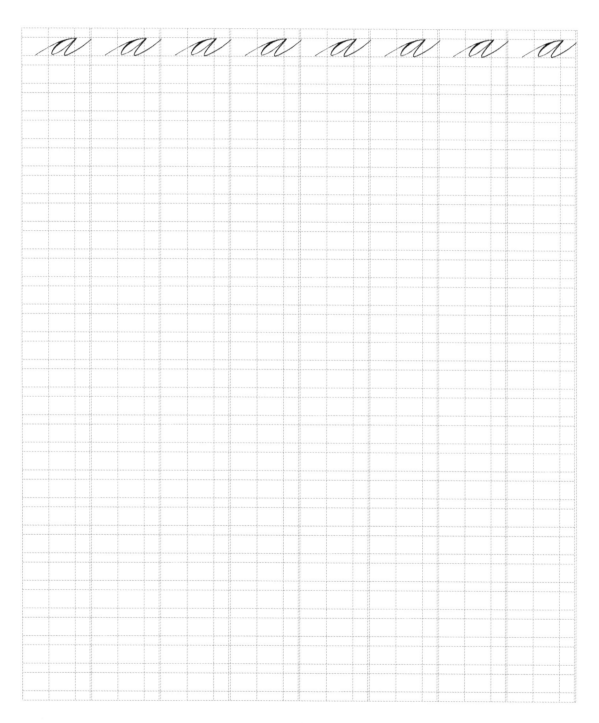

Small letter e (#86, page 19): ascending right curve; short left turn; descending left curve on steeper main slant, crossing previous curve one-third space from baseline; short right turn; ascending right curve. Loop is one-fourth spaces wide and two-third spaces long. Analysis of principles: 2, 3, 2.

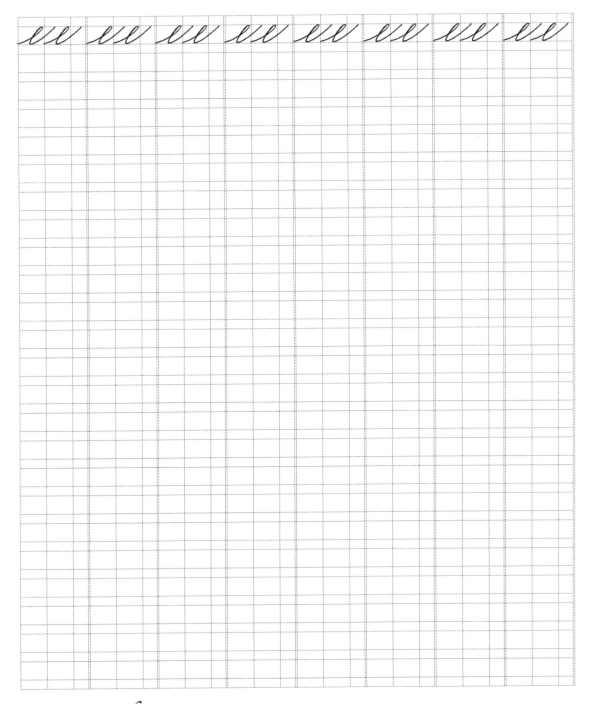

Small letter c (#88, page 19): ascending right curve almost one space high; angular joining; one-third space descending straight line, very short right turn; one-third space ascending right curve on steeper main slant; very short left turn; descending left curve, crossing first curve one-third space from baseline; short right turn; ascending right curve. Analysis of principles: 2, 1, 2, 3, 2.

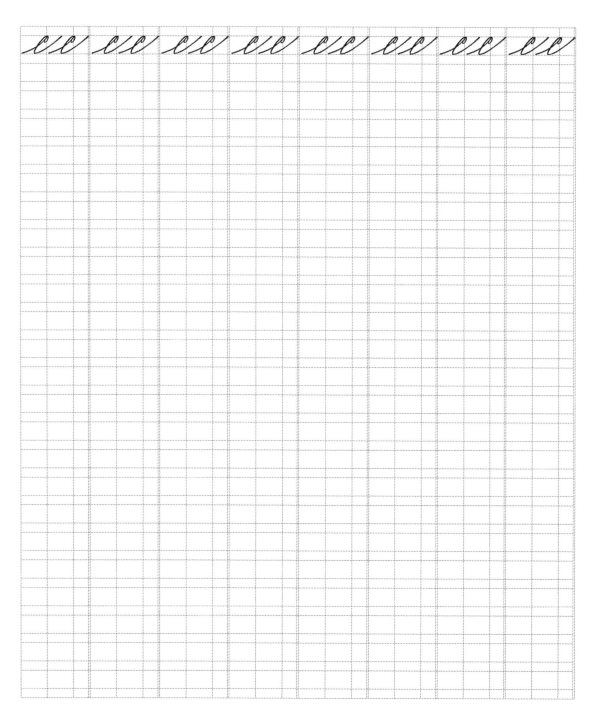

Small letter r (#90, page 19): ascending right curve one and one-quarter spaces tall; descending one-quarter space left curve on a slant only 5° to the left of vertical; very short left turn; descending straight line; short right turn; ascending right curve. Analysis of principles: 2, 3, 1, 2.

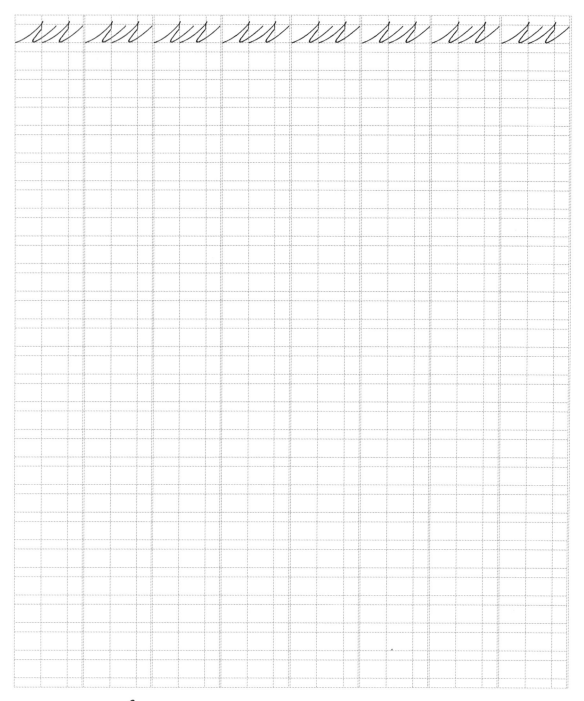

Theory *of* Spencerian Penmanship

Small letter s (#92, page 19): ascending right curve one and one-quarter spaces tall; angular joining; very slight left curve descending one-third spaces; gradual merge; descending right curve; short left turn that stops when it meets first curve one-quarter spaces above baseline; light dot; ascending right curve, retraces previous curve and then continues past. Analysis of principles: 2, 3, 2, 2.

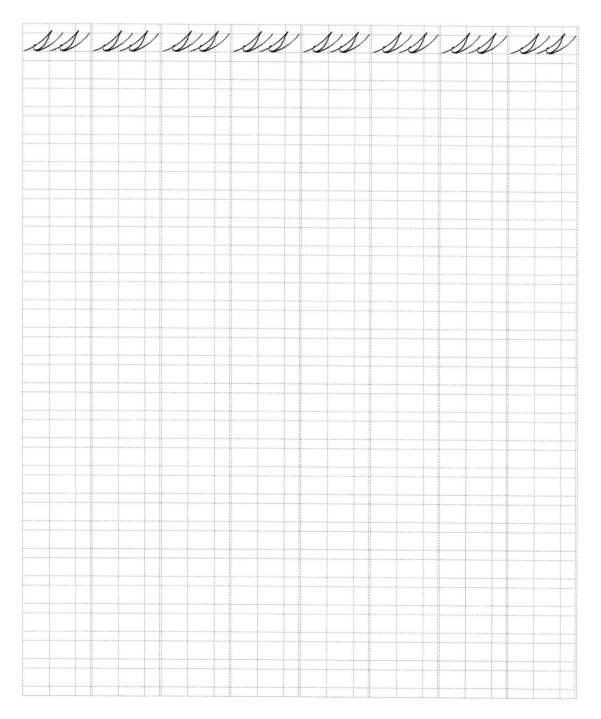

Small letter t (#98, page 20): ascending right curve on connected slant for one space and steeper main slant for second; angular joining; descending straight line; short right turn; ascending right curve one space; horizontal straight line placed on the stem one and one-half spaces above baseline. This crossing line is one space long with one-third on the left of the stem and two-thirds on the right. Analysis of principles: 2, 1, 2, 1.

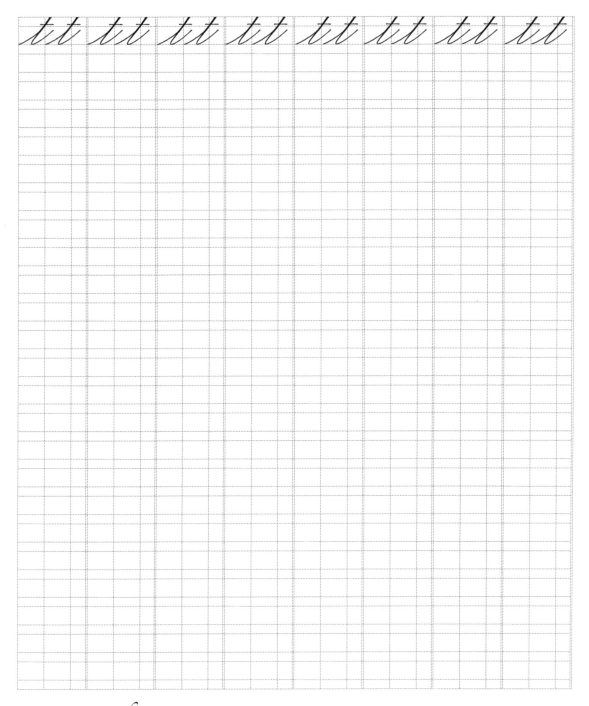

Small letter d (#100, page 20): form pointed direct oval as in *small a* (#84, page 18); from highest point continue with ascending straight line one space high; angular joining; descending straight line to base; short right turn; ascending right curve one space high. Analysis of principles: 3, 3, 2, 1, 2.

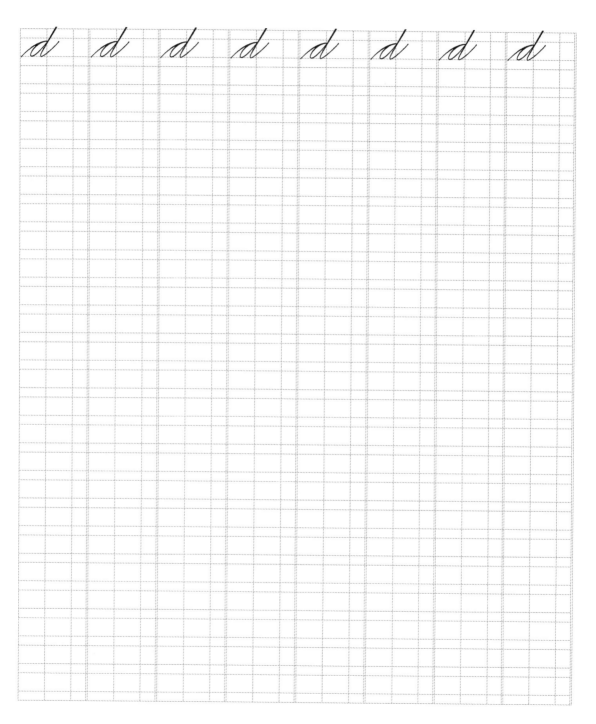

Small letter p (#102, page 20): ascending right curve on slant slightly left of connective slant; angular joining; descending straight line, crosses baseline and then descends a further one and one-half spaces (three and one-half spaces in total); retrace straight up to baseline; ascending left curve one space high; short right turn; descending straight line one space; short right turn; ascending right curve one space. Analysis of principles: 2, 1, 3, 1, 2.

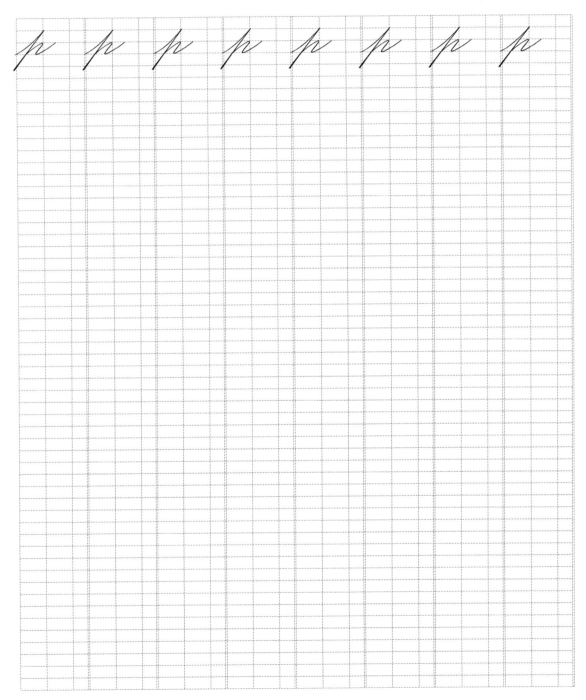

Small letter q (#104, page 21): form pointed direct oval as in *small letter a* (#84, page 18); angular joining at highest point; descending straight line to one and one-half spaces below baseline; short right turn; slight ascending right curve on steeper main slant up to baseline; ascending left curve one space high. Final left curve ends one space to right of pointed oval. Tail below baseline one-third spaces wide. Analysis of principles: 3, 3, 2, 1, 2, 3.

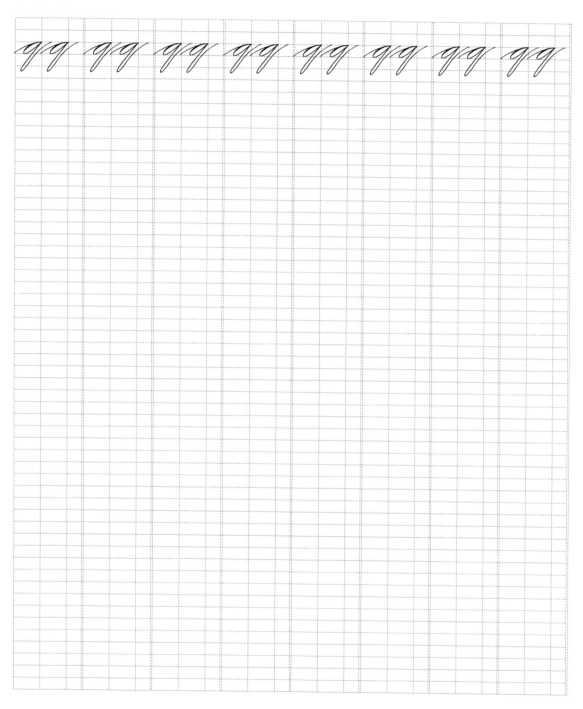

The *Fourth Principle* (#106, page 21) is also called the Extended Loop. Begin on baseline, and ascend with a right curve three spaces; turn short, and descend with a slight left curve on main slant two spaces; then crossing first curve, continue with a straight line on main slant to base.

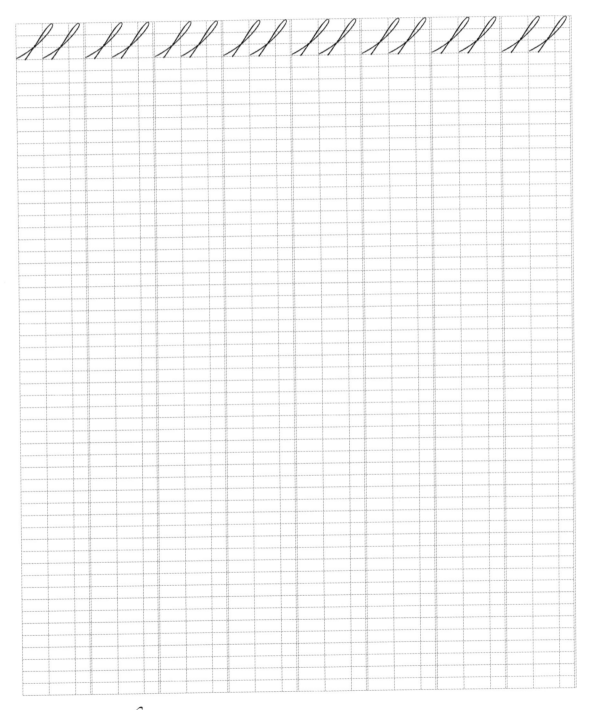

Small letter h (#111, page 21): form extended loop; angular joining; final three strokes of *small letter n* (#74, page 17). Analysis of principles: 4, 3, 1, 2.

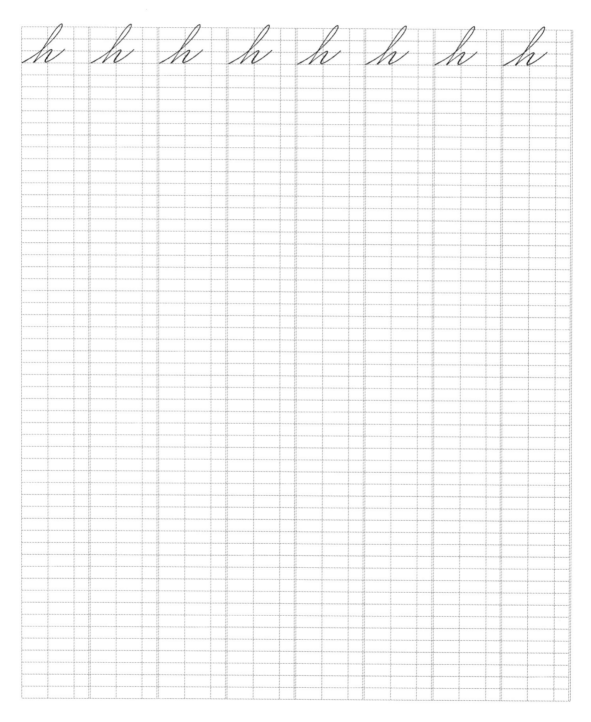

Small letter k (#113, page 21): form extended loop; angular joining; ascending left curve one and one-fourth spaces high and one space to right of loop crossing; horizontal right curve to left one-half space, stopping one space above baseline; angular joining; descending straight line; short right turn; ascending right curve one space high. Analysis of principles: 4, 3, 2, 1, 2.

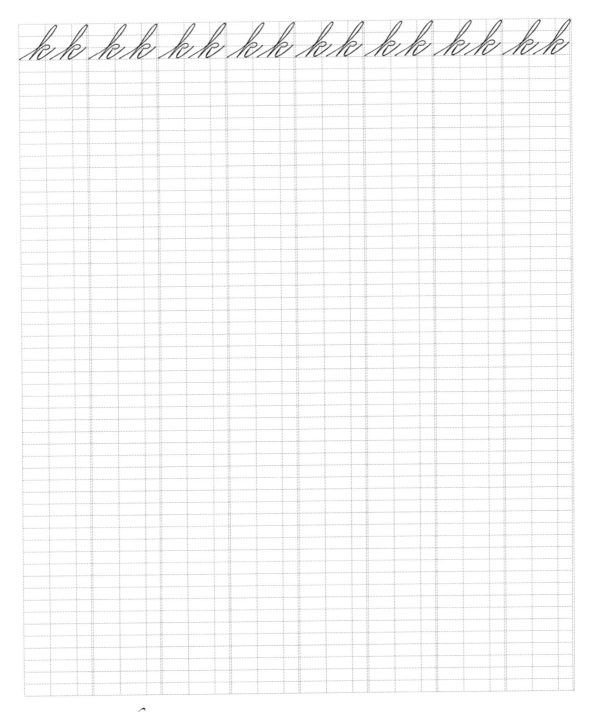

Small letter l (#115, page 22): form extended loop; short right turn; ascending right curve one space high. Analysis of principles: 4, 2.

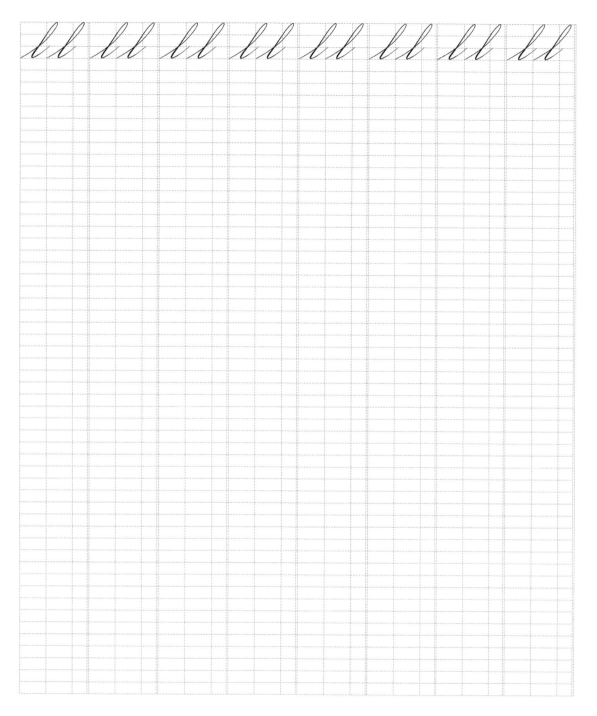

Small letter b (#117, page 22): form extended loop; short right turn; ascending right curve one space high, light dot, horizontal right curve one-half space long. Dot is one-half space to right of loop crossing point. Analysis of principles: 4, 2, 2.

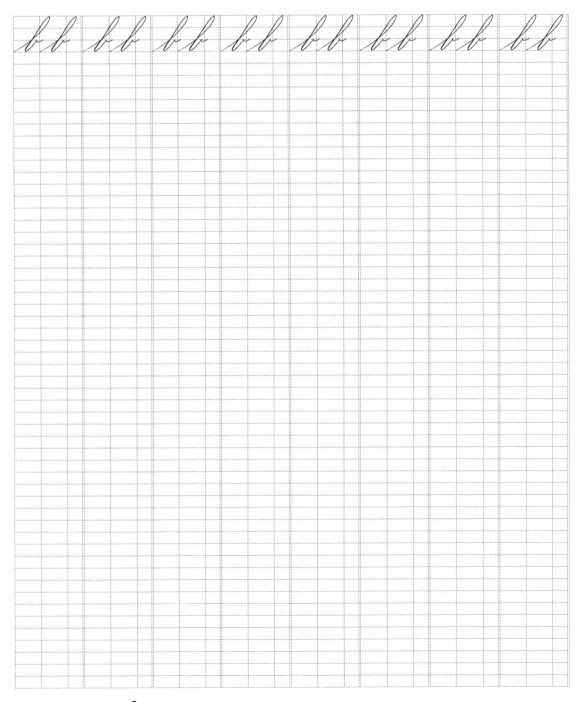

Small letter j (#119, page 22): ascending right curve one space high; angular joining; descending straight line one space down to baseline; descending gentle right curve on steeper main slant to two spaces below baseline; short left turn; ascending left curve that crosses baseline and continues ascending for one more space; place dot one space above straight line on main slant. Analysis of principles: 2, 4, dot.

Small letter y (#121, page 22): ascending left curve one space high; short right turn; descending straight line one space long; finish just like *small letter j* without a dot. *Small letter y* is *small letter h* inverted. Analysis of principles: 3, 1, 2, 4.

Small letter g (#123, page 22): form pointed direct oval as in *small letter a* (#84, page 18); from highest point, finish with last steps of *small letter j*. Analysis of principles: 3, 3, 2, 4.

Small letter z (#125, page 23): ascending left curve one space high; right turn one-quarter space wide; descending straight line one space long; angular joining at baseline; short right turn identical to first; descending right curve two spaces below baseline; short left turn; ascending left curve up to baseline and continuing one space higher. Loop is one-half spaces wide. Analysis of principles: 3, 1, 4.

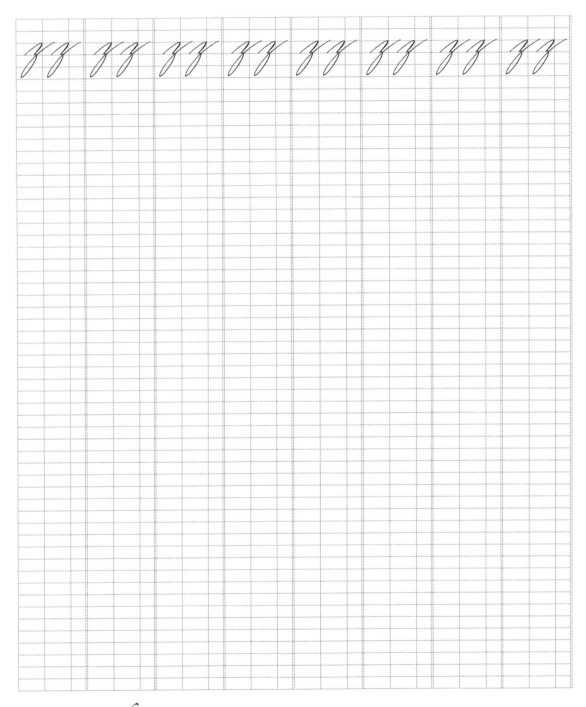

Theory *of* Spencerian Penmanship

Small letter f (#127, page 23): extended loop; descending slight left curve on steeper main slant to two spaces below baseline; short right turn; ascending right curve meets descending left curve one-half space above baseline; angular joining; ascending right curve ending one space above baseline and one space to right of loop closing point. Each loop is one-half space wide. Analysis of principles: 4, 3, 2, 2.

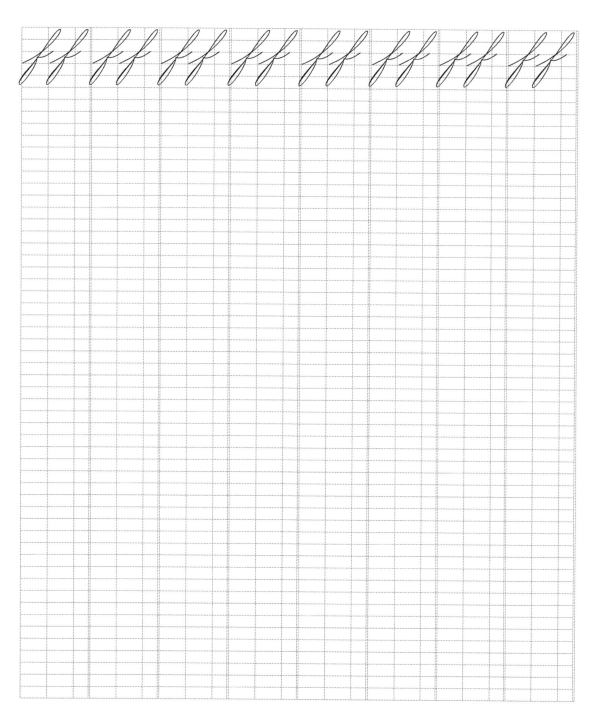

Practice *figures 1* through *9* (starting on page 36): *Figures 6, 7,* and *9* are two spaces in height; all others are one and one half spaces in height. *Figure 0* is one-half space in width; all others are one space in width. Read the handbook for more details on forming *figures*. Analysis of principles: *Figure 0:* 3, 2. *Figure 1:* 1. *Figure 2:* 2, 3, 2, 3, 2. *Figure 3:* 2, 3, 2, 2, 3. *Figure 4:* 2, 3, 2. *Figure 5:* 2, 2, 3, 1. *Figure 6:* 3, 2, 3. *Figure 7:* 1, 3, 2, 1. *Figure 8:* 2, 3, 2, 3. *Figure 9:* 3, 2, 1.

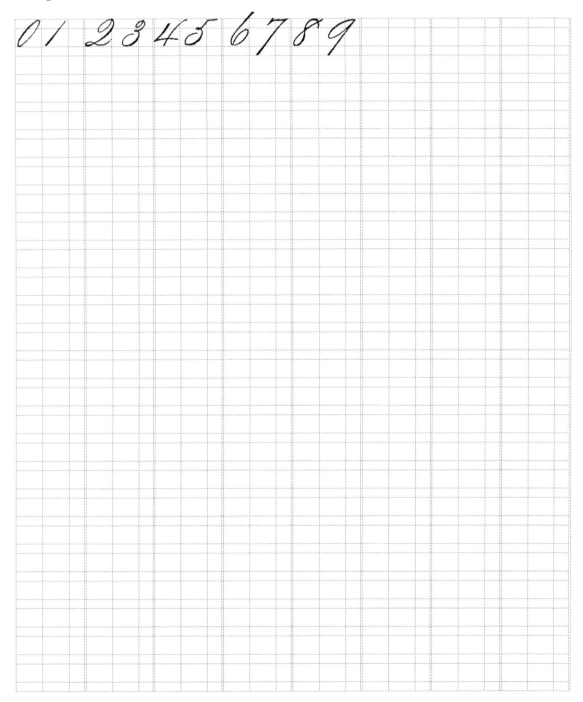

Theory *of* Spencerian Penmanship

Practice writing words without lifting the pen between letters. As you write the word *air*, notice that the letters connect in *simple curves*; each letter ends in the exact same curve with which the next letter begins. The distance between the letters of simple curves is one space. Do not forget to extend *r* to one-fourth space higher than the other letters. Wait until the word is completed to dot the *i*. Analysis of principles: 3, 3, 2, 1, 2, 1, 2, 3, 1, 2, dot.

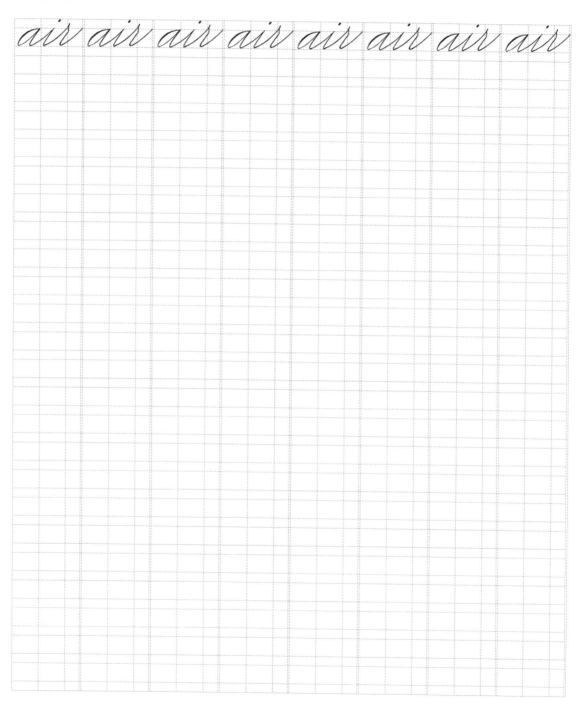

As you write the word *see*, notice that the letters connect in simple curves. Do not forget to extend *s* to one-fourth space higher than the other letters. Analysis of principles: 2, 3, 2, 2, 3, 2, 3, 2.

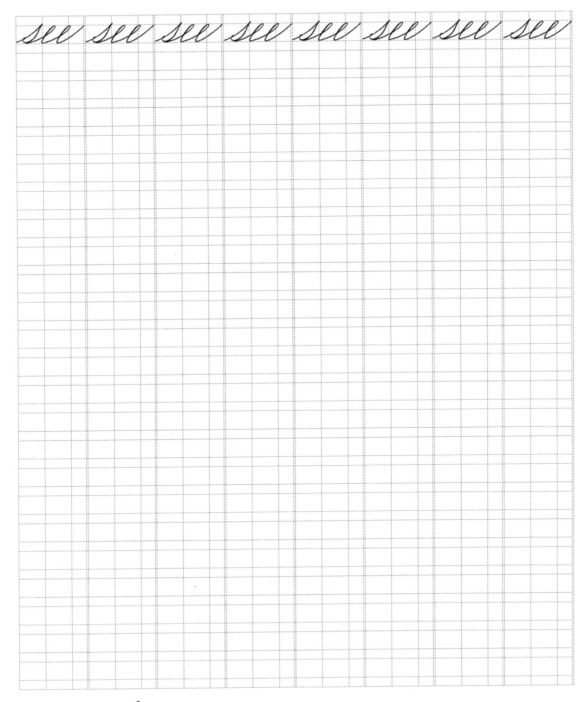

Theory *of* Spencerian Penmanship

As you write the combination *ne*, notice that the letters connect in simple curves. Analysis of principles: 3, 1, 3, 1, 2, 3, 2.

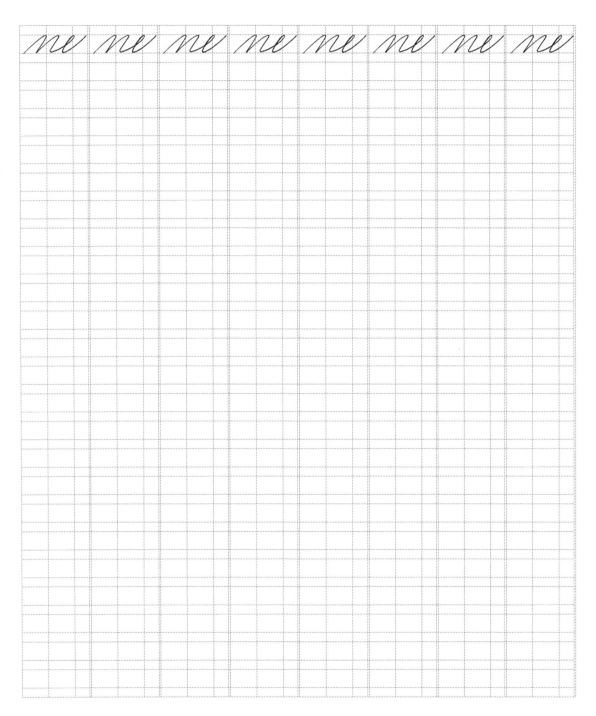

As you write the combination *ici*, notice that the letters connect in simple curves. Wait until the word is completed to dot the *i*'s. Analysis of principles: 2, 1, 2, 1, 2, 3, 2, 1, 2, dot, dot.

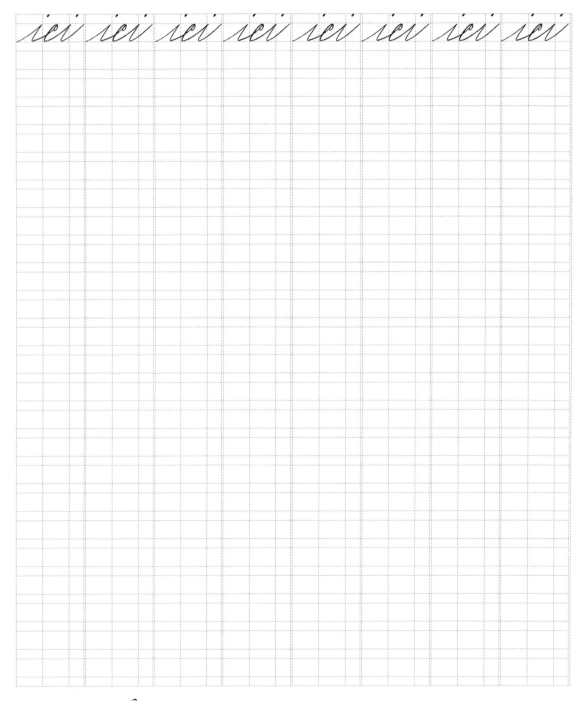

As you write the word *ow*, notice that the final horizontal right curve of the *o* is used as the beginning right curve of the *w*, which is a change from the vertical right curve with which an unconnected *w* begins. In all cases where letters are joined from top to top, such as *o* and *w*, the distance between them is one space. Be careful to close the *o* at the top. Analysis of principles: 3, 3, 2, 2, 1, 2, 1, 2, 2.

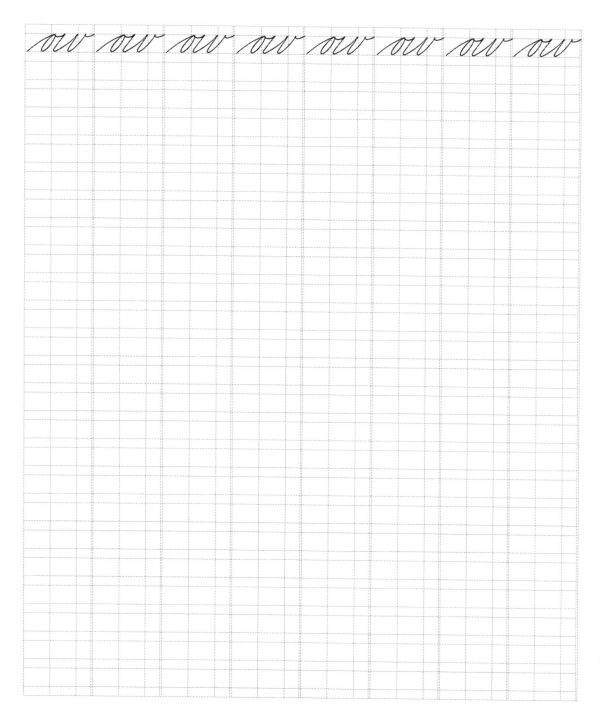

As you write the word *us*, notice that the letters connect in simple curves. Do not forget to extend *s* to one-fourth space higher than *u*. Analysis of principles: 2, 1, 2, 1, 2, 3, 2, 2.

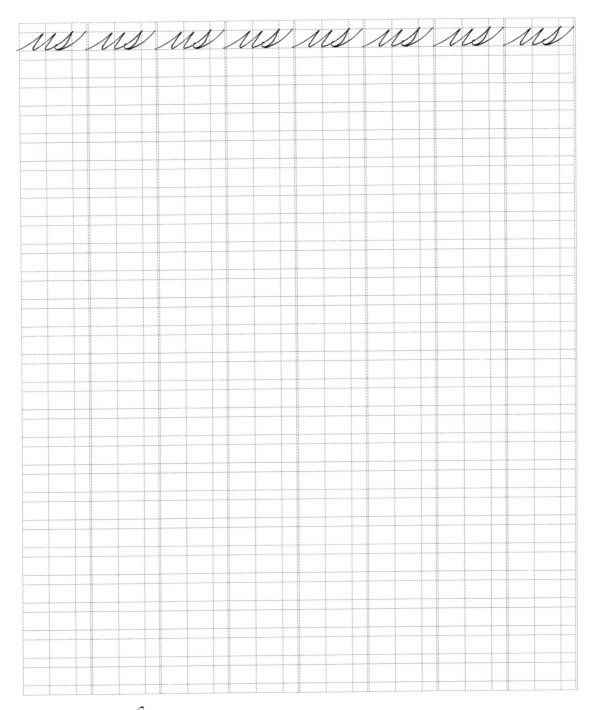

Theory *of* Spencerian Penmanship

As you write the combination *xv*, notice that the letters connect in a *compound curve*, the combination of two different kinds of curves. In this example, the *x*'s final right cure gradually becomes the *v*'s initial left curve. The distance between the letters of complex curves is one and one-third space. Analysis of principles: 3, 2, 3, 2/3, 1, 2, 2.

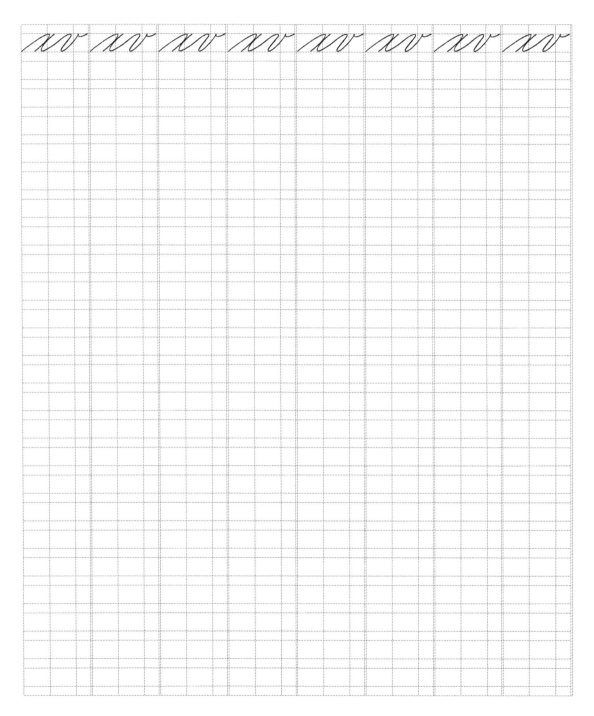

Combine each slanted straight line with the next in order to perfect the *First Principle* (#63, page 16), practice angular joinings, and produce a free movement of the forearm. Do not lift your pen from the page between sets. Analysis of principles: 1 thirteen times.

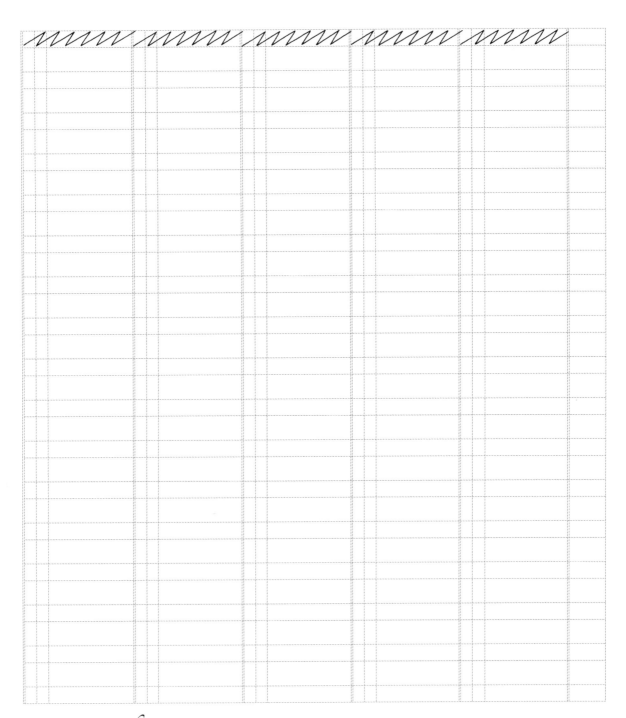

Theory *of* Spencerian Penmanship

As you write the combination *iiuw*, notice that the letters connect in simple curves. Be careful to avoid accidentally adding or subtracting a curve or two; this is a common mistake given the similarity of the letters. Wait until the combination is completed to dot the *i*'s. Analysis of principles: 2, 1, 2, 1, 2, 1, 2, 1, 2, 1, 2, 1, 2, 2, dot, dot.

As you write the word *nun*, notice that while the first *n* and *u* connect in a simple curve, the *u* and second *n* connect in a compound curve. Analysis of principles: 3, 1, 3, 1, 2, 1, 2, 1, 2/3, 1, 3, 1, 2.

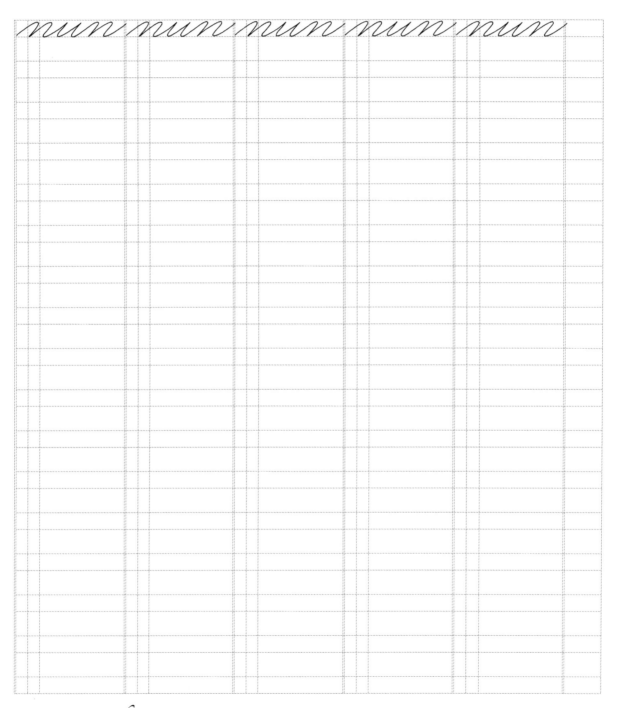

Theory *of* Spencerian Penmanship

As you write the combination *miu*, notice that the letters connect in simple curves. Wait until the combination is completed to dot the *i*. Be careful to keep straight lines parallel and curves of the same length and slant. Analysis of principles: 3, 1, 3, 1, 3, 1, 2, 1, 2, 1, 2, 1, 2, dot.

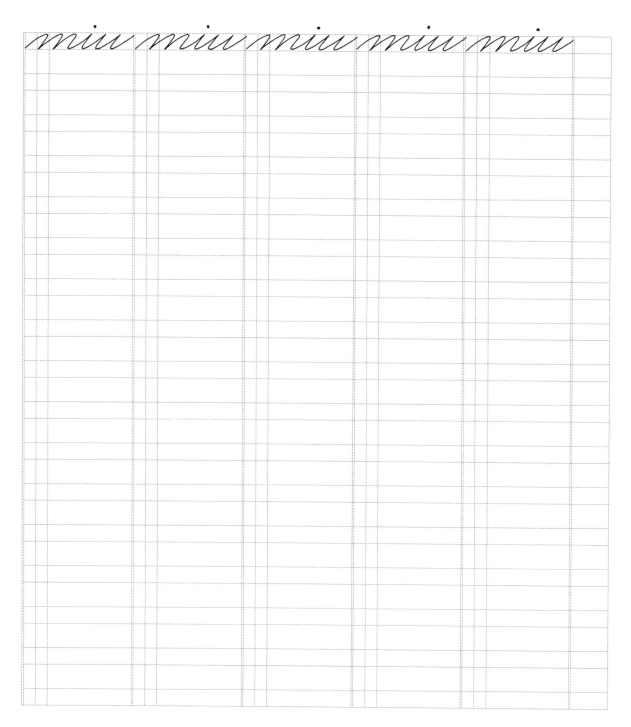

As you write the combination *nxxv*, notice all letters connect in compound curves. Wait until the combination is completed to cross the *x*'s. Analysis of principles: 3, 1, 3, 1, 2/3, 2, 3, 2/3, 2, 3, 2/3, 1, 2, 2.

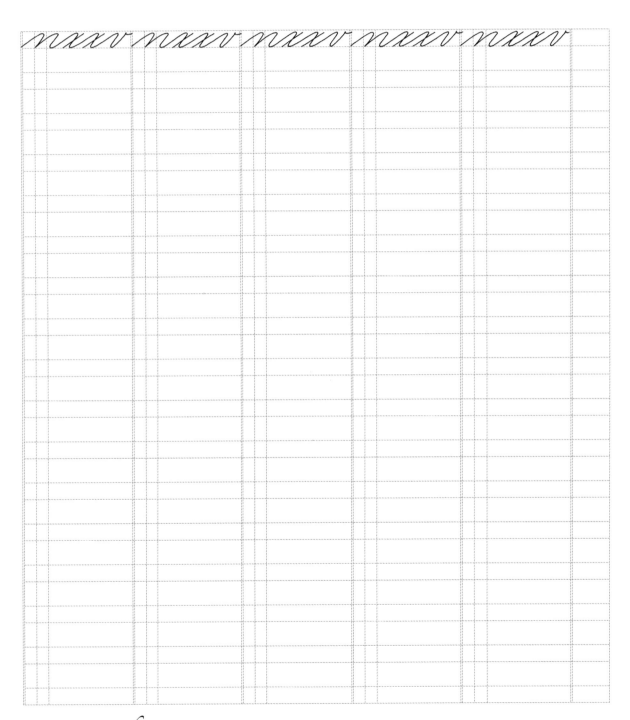

Theory *of* Spencerian Penmanship

As you write each set of connected *o*'s, notice that the final horizontal right curve of each *o* is used as the beginning right curve of the next *o*, which is a change from the vertical right curve with which the letter usually begins. Be careful to close each *o* at the top. Analysis of principles: 3, six repetitions of 3, 2, 2.

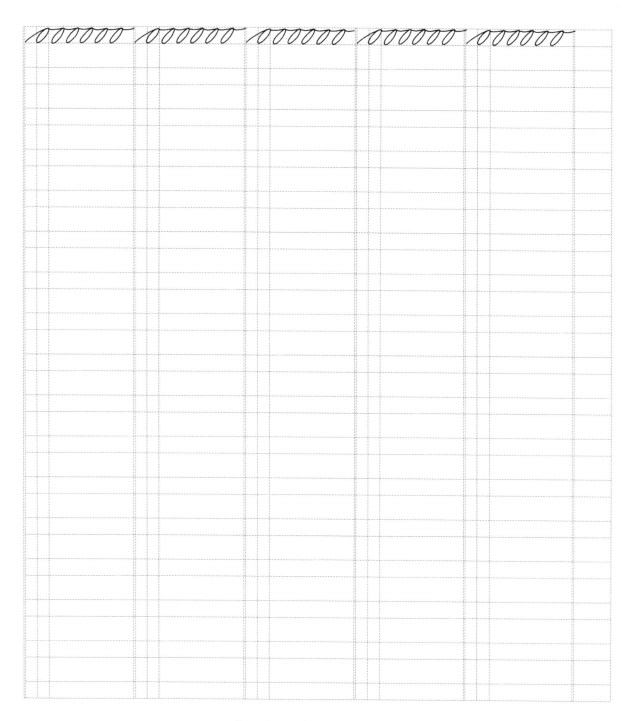

Practicing Principles of Small Letters in Combination 81

As you write the combination *nim*, notice that the *n* and *i* connect with a simple curve, while the *i* and *m* connect with a compound curve. Remember when the simple curve is employed, there is one space between letters. When the compound curve occurs, there is one and one-third space between letters. Wait until the combination is completed to dot the *i*. Analysis of principles: 3, 1, 3, 1, 2, 1, 2/3, 1, 3, 1, 3, 1, 2, dot.

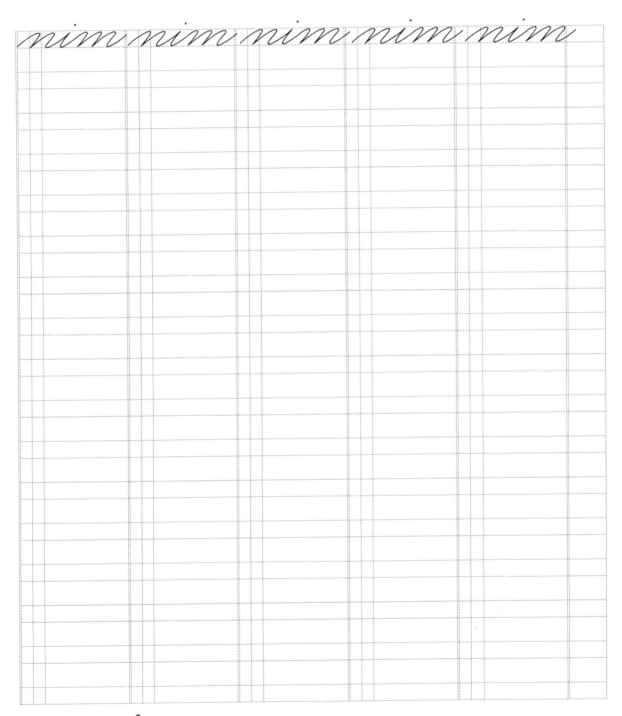

Theory *of* Spencerian Penmanship

As you write each set of connected *a*'s, notice that they all connect in compound curves. Be careful to close each *a* at the top. When retracing the initial left curve of each *a*, do not diverge from the first curve until one-half space above the baseline. Analysis of principles: 3, 3, 2, 1, 2 repeated 3 times.

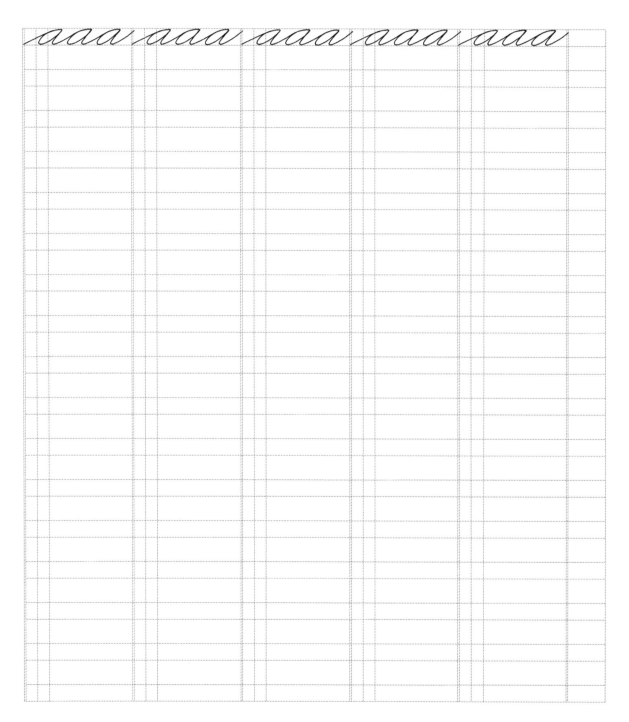

Practicing Principles of Small Letters in Combination 83

As you write the word *aim*, notice that the *a* and *i* connect with a simple curve, while the *i* and *m* connect with a compound curve. Wait until the word is completed to dot the *i*. Analysis of principles: 3, 3, 2, 1, 2, 1, 2,/3, 1, 3, 1, 3, 1, 2, dot.

aim aim aim aim aim

As you write each set of connected *e*'s, notice that they all connect in simple curves. Complete the loop one-third space above the baseline. Avoid too full curves so as not to produce too large loops. Analysis of principles: 2, 3 repeated six times, 2.

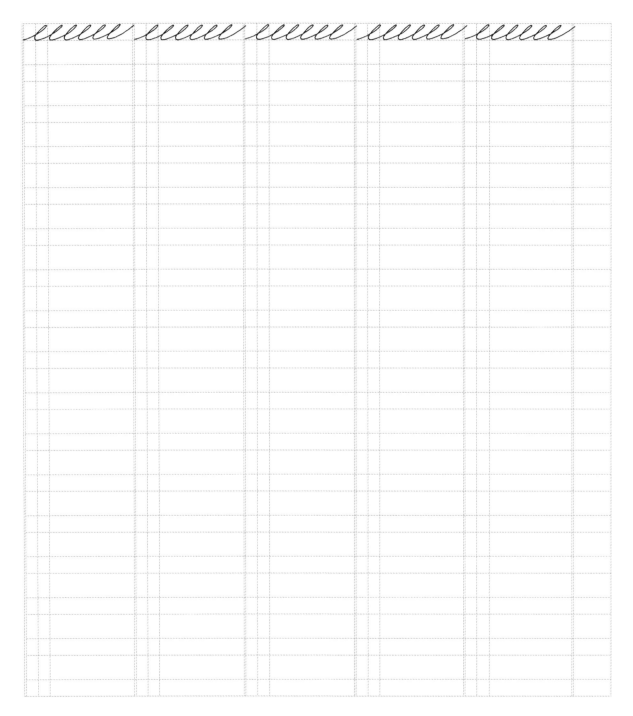

As you write the word *men*, notice that the *m* and *e* connect with a simple curve, while the e and *n* connect with a compound curve. All letters should be on the same slant. Analysis of principles: 3, 1, 3, 1, 3, 1, 2, 3, 2/3, 1, 3, 1, 2.

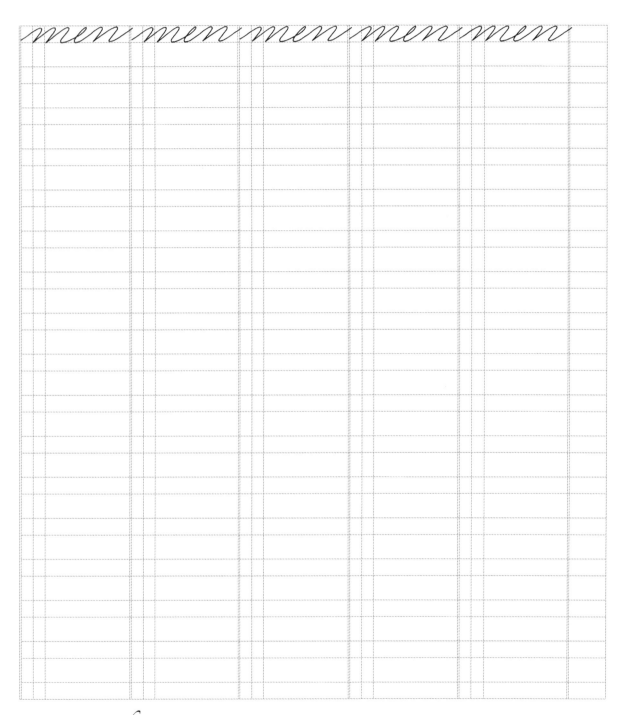

Theory *of* Spencerian Penmanship

As you write each set of connected *c*'s, notice that they all connect in simple curves. Complete the loop one-third space above the baseline. Avoid too large loops and too round or straight a left curve. Analysis of principles: repeat 2, 1, 2, 3 six times, 2.

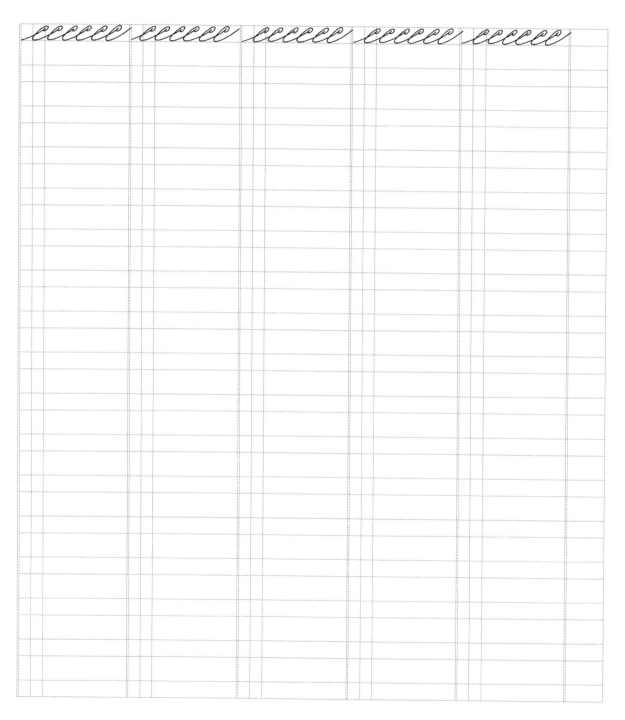

As you write the combination *cam*, notice that the letters connect in compound curves. Also notice that the *c*'s left curve is shorter and on a more gradual tilt than the *a*'s left curve. Analysis of principles: 2, 1, 2, 3, 2/3, 3, 2, 1, 2/3, 1, 3, 1, 3, 1, 2.

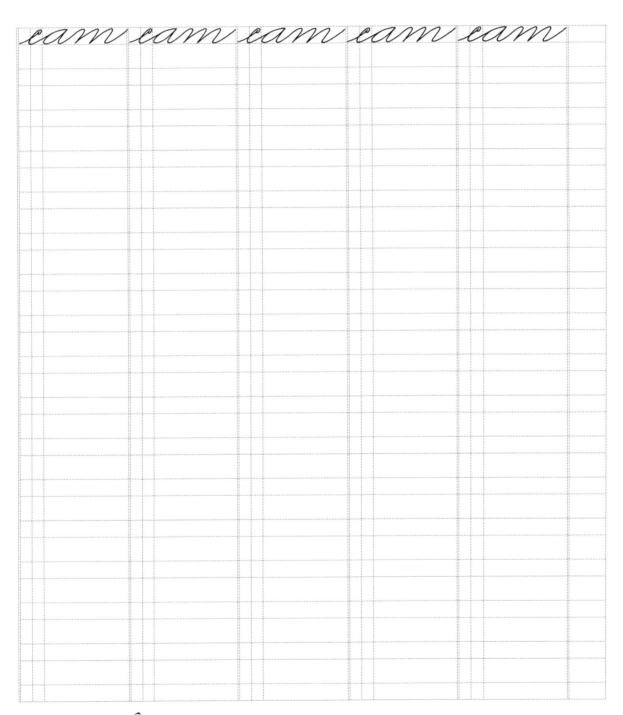

Theory of Spencerian Penmanship

As you write each set of connected *r*'s, notice that they all connect in simple curves. Remember that the initial right curve of the *r* is one and one-fourth space high, taller than most other small letters. Keep the left curve at the shoulder short and slight in order to avoid looping or too much width. Analysis of principles: 2, 3, 1, 2 repeated six times, 2.

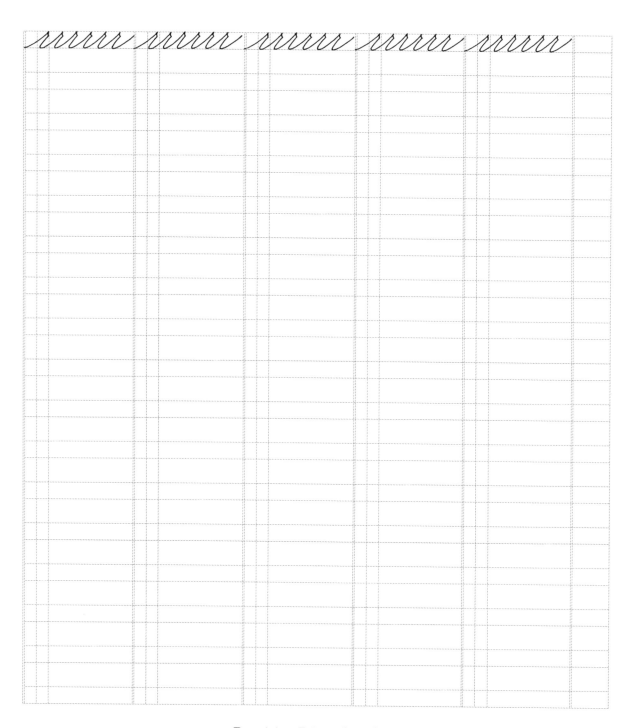

As you write the word *ruin*, notice that the first three letters connect in simple curves, while the *i* and *n* connect in a compound curve. Remember that the initial right curve of the r is one-fourth space taller than the other letters. Wait until the word is completed to dot the *i*. Analysis of principles: 2, 3, 1, 2, 1, 2, 1, 2, 1, 2/3, 1, 3, 1, 2, dot.

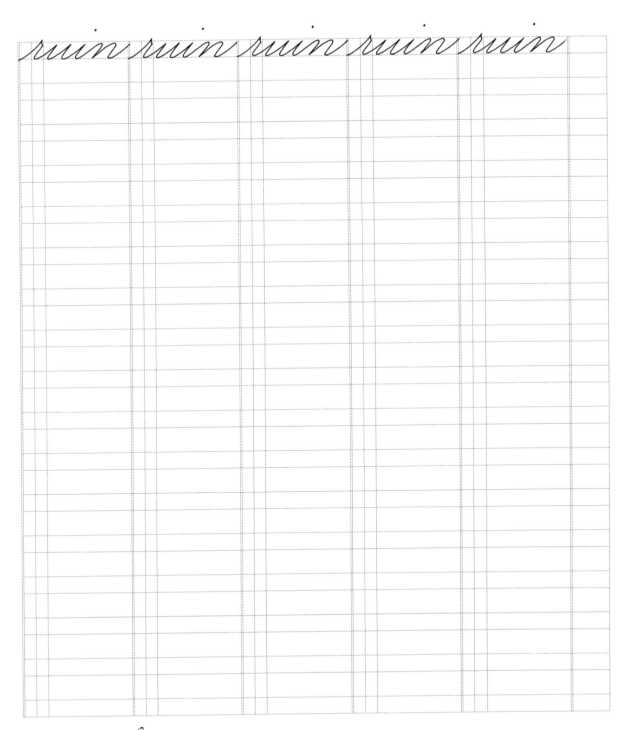

Theory of Spencerian Penmanship

As you write each set of connected *s*'s, notice that they all connect in simple curves. Remember that the initial right curve of the *s* is one and one-fourth space high, taller than most other small letters. Avoid too much width. Analysis of principles: 2, 3, 2 repeated six times, 2.

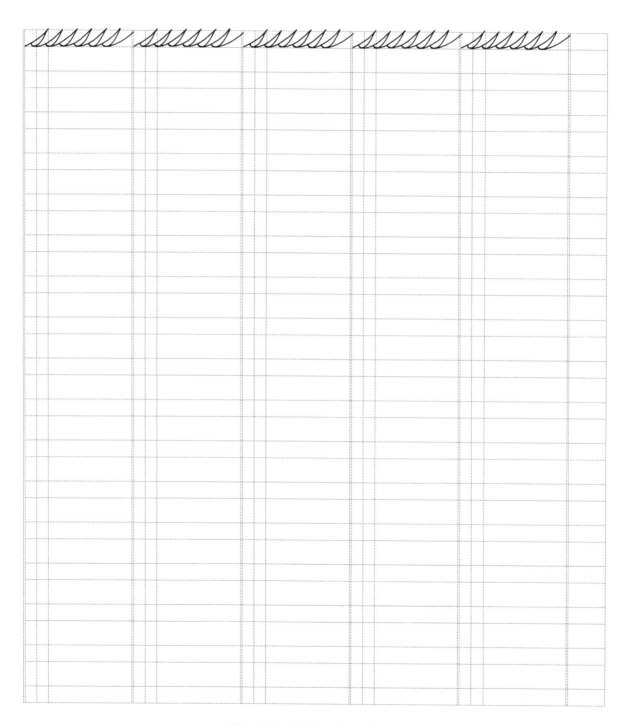

As you write the word *some*, notice that the *s* and *o* connect in a compound curve, the *o* and *m* use the horizontal right curve of the *o* as the beginning right curve of the *m*, and the *m* and *e* connect in a simple curve. Analysis of principles: 2, 3, 2, 2/3, 3, 2, 2/3, 1, 3, 1, 3, 1, 2, 3, 2.

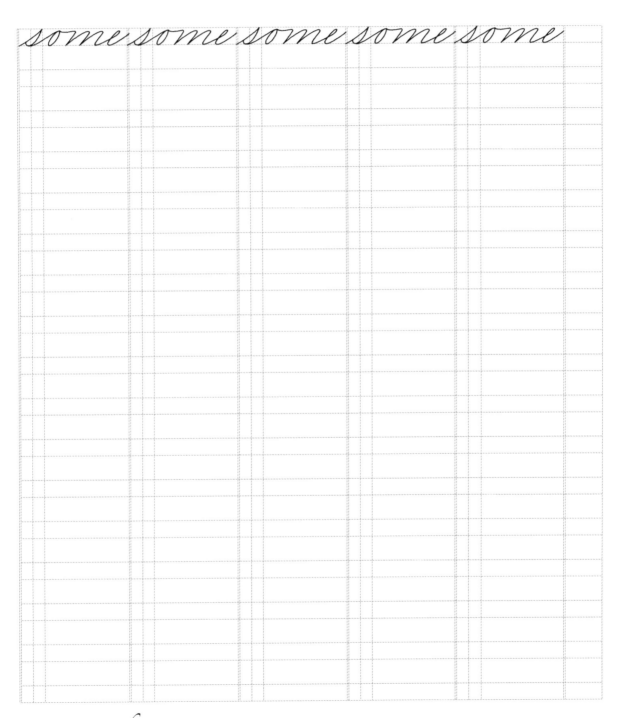

Theory *of* Spencerian Penmanship

As you write the word *sum*, notice that the *s* and *u* connect in a simple curve, while the *u* and *m* connect in a compound curve. Analysis of principles: 2, 3, 2, 2, 1, 2, 1, 2/3, 1, 3, 1, 3, 1, 2.

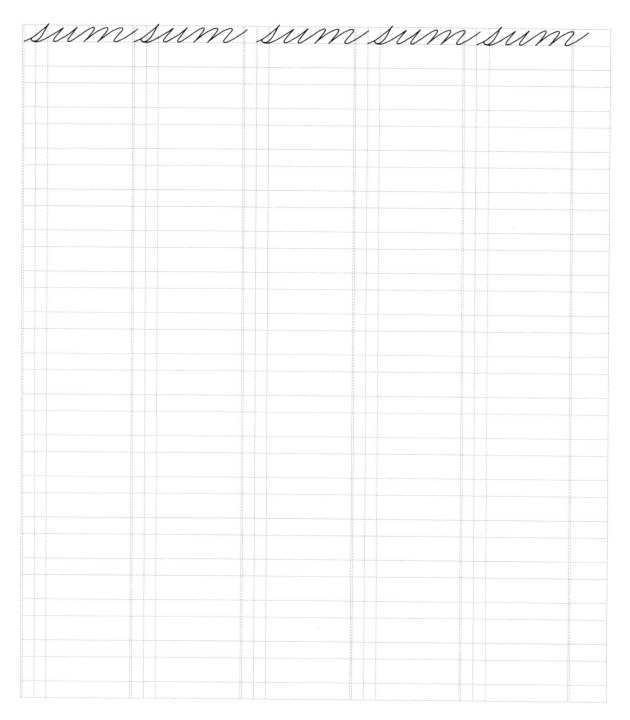

As you write the combination *utui*, notice that the letters all connect in simple curves. Remember that the *t* is two spaces high while the other letters are each one space high. Wait until the combination is completed to cross the *t* and dot the *i*. Analysis of principles: 2, 1, 2, 1, 2, 1, 2, 1, 2, 1, 2, 1, 2, cross 1, dot.

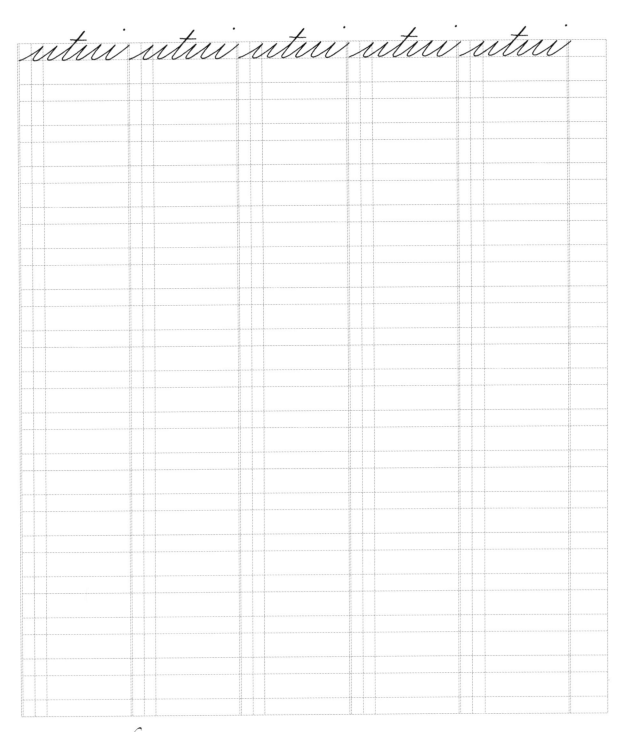

Theory *of* Spencerian Penmanship

As you write the word *dim*, notice that the *d* and *i* connect in a simple curve while the *i* and *m* connect in a compound curve. Remember that the *d* is two spaces high while the other letters are each one space high. Wait until the word is completed to dot the *i*. Analysis of principles: 3, 3, 2, 1, 2, 1, 2/3, 1, 3, 1, 3, 1, 2, dot.

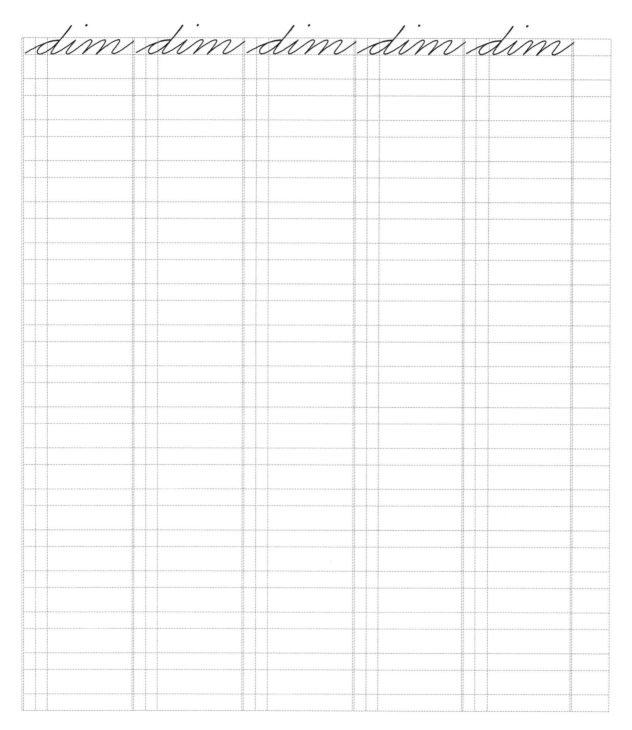

As you write the combination *mew*, notice that the letters all connect in simple curves. Analysis of principles: 3, 1, 3, 1, 3, 1, 2, 3, 2, 1, 2, 1, 2, 2.

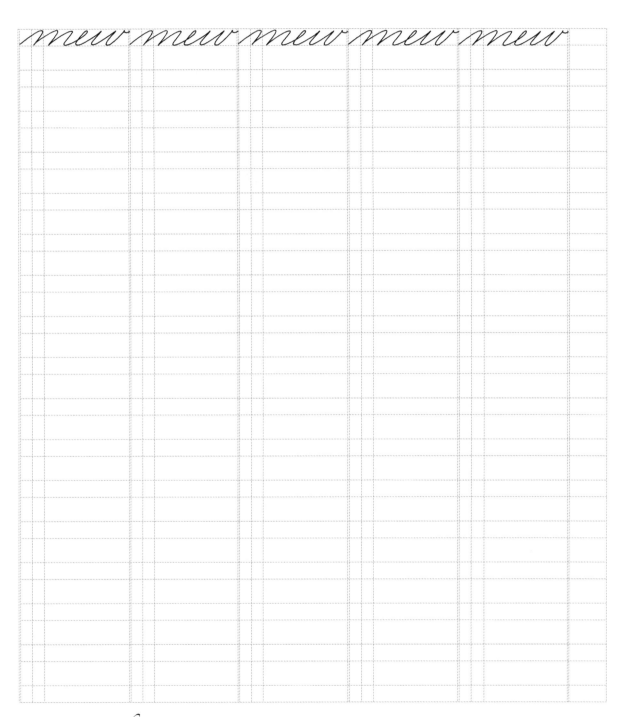

Theory *of* Spencerian Penmanship

As you write the word *max*, notice that the letters all connect in compound curves. Analysis of principles: 3, 1, 3, 1, 3, 1, 2/3, 3, 2, 1, 2/3, 2, 3, 2.

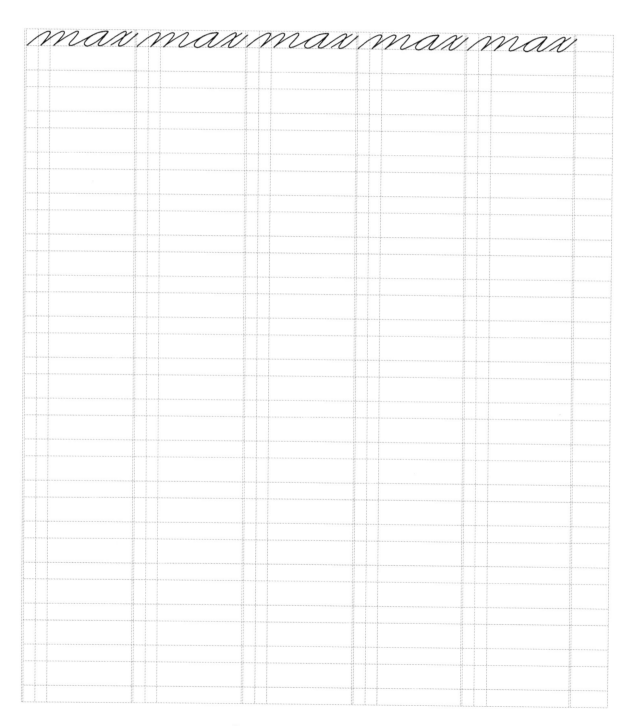

As you write the word *mice*, notice that the letters all connect in simple curves. Wait until the word is completed to dot the *i*. Analysis of principles: 3, 1, 3, 1, 3, 1, 2, 1, 2, 1, 2, 3, 2, 3, 2, dot.

mice mice mice mice mice

As you write the word *vain*, notice that the *v* and *i* use the horizontal right curve of the *v* as the beginning left curve of the *a*, the *a* and *i* connect in a simple curve, and the i and n connect in a compound curve. Wait until the word is completed to dot the *i*. Analysis of principles: 3, 1, 2, 2/3, 3, 2, 1, 2, 1, 2/3, 1, 3, 1, 2, dot.

As you write the combination *mere*, notice that the letters all connect in simple curves. Remember that the initial right curve of the *r* is one-fourth space taller than the other letters in the combination. Analysis of principles: 3, 1, 3, 1, 3, 1, 2, 3, 2, 3, 1, 2, 3, 2.

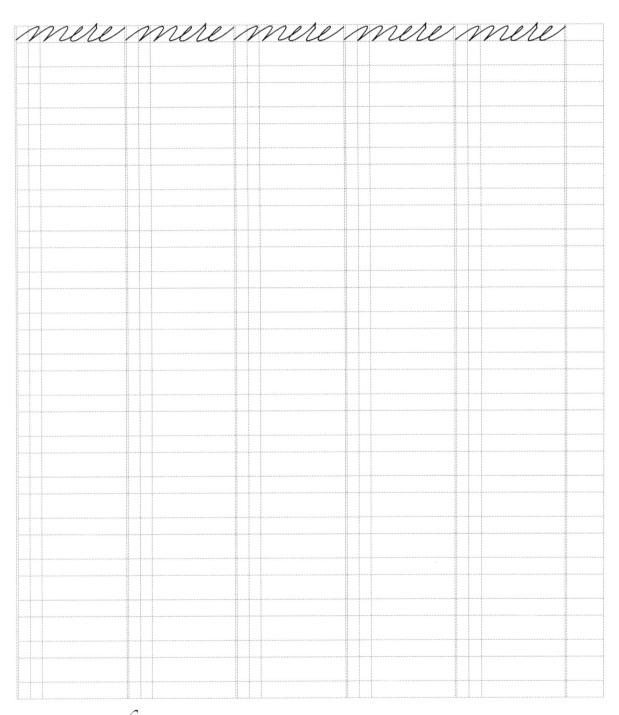

As you write each set of connected *u*'s, notice that they all connect in simple curves Also notice that with dots added, these could be changed into eight connected *i*'s due to the to letters sharing principles. Analysis of principles: 2, 1, 2, 1 repeated four times, 2.

As you write the combination *wwwi*, notice that all the letters use the final horizontal right curve of each *w* as the beginning right curve of the next letter, which is a change from the vertical right curve with which the letters *w* and *i* usually begin. Wait until the combination is completed to dot the *i*. Analysis of principles: 2, 1, 2, 1, 2 repeated three times, 2, 1, 2, dot.

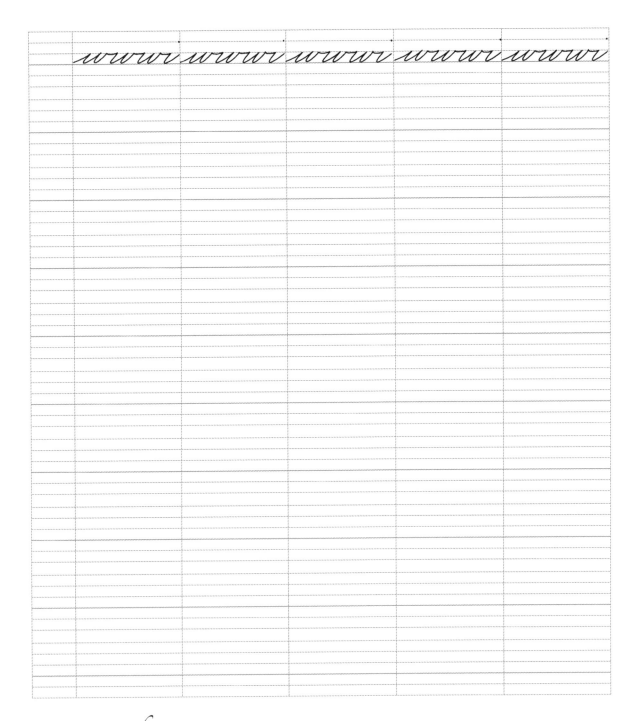

As you write the combination *nnm*, notice that all the letters connect in compound curves. These compound curves create one and one-third space between the letters to help differentiate them. Analysis of principles: 3, 1, 3, 1, 2/3, 1, 3, 1, 2/3, 1, 3, 1, 3, 1, 2.

As you write each set of connected *v*'s, notice that the final horizontal right curve of each *v* becomes a compound curve that serves as the beginning horizontal left curve of the next *v*. This is a change from the vertical left curve with which the letter usually begins. Analysis of principles: 3, 1, 2, 2 repeated six times.

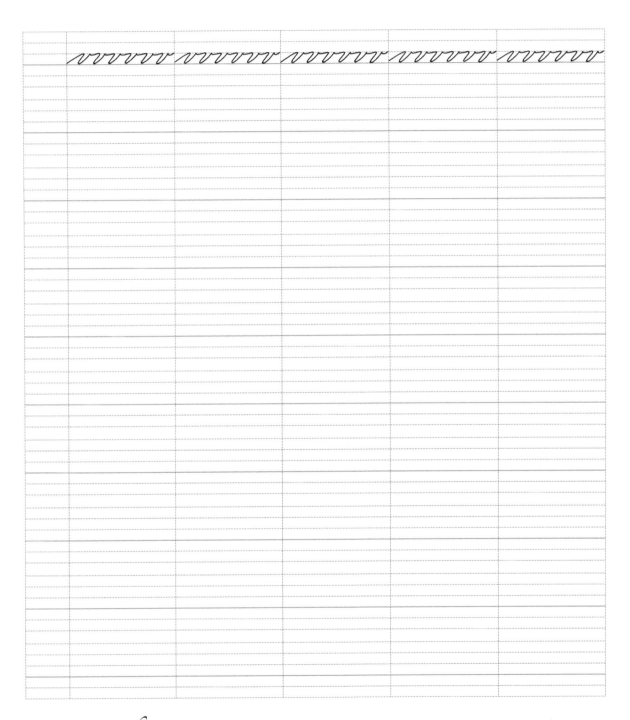

As you write each set of connected *x*'s, notice that they all connect in compound curves. (This is the primary method of creating the *x*. See the note for #80 on page 18 for an alternate way of writing the *small letter x*.) Analysis of principles: 3, 2, 3, 2 repeated six times.

As you write the combinations and words *minu, mince, mini, saxon, venue, venus, warm,* and *miner,* take note of the types of connections between the letters. Remember that simple curves are one space wide, connections of letters that join from the top are one space wide, and compound curves are one and one-third spaces wide.

minu mince mini saxon

venue venus warm miner

Theory *of* Spencerian Penmanship

As you write the combinations and words *ututu*, *unites*, *mind*, and *adad*, take note of the types of connections between letters.

ututu ututu unites unites

mind mind adad adad

As you write the combinations and words *ipupi*, *repine*, *aquq*, *aqua*, *ihnhi*, and *iknku*, take note of the types of connections between letters.

ipupi repine aquq aqua

ihnhi iknku ihnhi iknku

As you write the combinations and words *ululu*, *ububi*, *nyny*, and *nijnij*, take note of the types of connections between letters.

ululu ububi ululu ububi

nyny nijnij nyny nijnij

As you write the combinations and words *agago*, *nznzn*, and *mfim*, take note of the types of connections between letters.

agago agago agago agago

nznzn mfim nznzn mfim

Practice the Capital Letters (starting on page 24) in combination with small letters. Capital letters are three spaces high unless otherwise specified. Start with the first class of capital letters, the *Fifth Principle letters*.

Capital letter O (#136, page 24) is the *Fifth Principle*, the Direct Oval. Start with descending left curve.

Capital letter E (#145, page 25): loop; descending left curve; finish with direct oval. Analysis of principles: 3, 2, 3, 5.

O Omen Omen Omen Omen Omen

E Enim Enim Enim Enim Enim

Capital letter D (#147, page 25): starts two and one-half spaces above the baseline; descending left curve one-half space, right curve one and one-half spaces and left curve one-half space, all on main slant; short left turn; ascending left curve three-quarters space, crossing stem; descending right curve one-quarter space and then left curve one-quarter space, both on oblique slant; finish like end of *capital letter O*. Analysis of principles: 3, 2, 3, 2, 3, 2, 3.

Capital letter C (#149, page 26): loop; reversed direct oval; ascending right curve. Analysis of principles: 3, 2, 3, 2.

Theory *of* Spencerian Penmanship

The *Sixth Principle* (#139, page 25), the Reversed Oval, starts on baseline; ascending left curve on the main slant three spaces; right oval turn; descending right curve to base. Practice the *Sixth Principle* letters.

Capital letter X (#152, page 26): reversed oval; left descending curve; right ascending curve. Analysis of principles: 6, 3, 2.

Capital letter W (#154, page 26): reversed oval; ascending slight right curve; descending slight left curve; ascending left curve; after oval all joinings are angular. Analysis of principles: 6, 2, 3, 3.

Capital letter Q (#156, page 27): reversed oval that closes; loop; ascending right curve. Analysis of principles: 6, 3, 2.

Capital letter Z (#158, page 27): reversed oval; loop one space long; loop as in *small letter z*. Analysis of principles: 6, 3, 2, 4.

Capital letter V (#160, page 27): reversed oval ending at upper third of right side; descending straight line; ascending right and left curve. Analysis of principles: 6, 2, 3.

Capital letter U (#162, page 28): reversed oval as in *capital letter V*; ascending right curve; angular joining; descending straight line; ascending right curve. Analysis of principles: 6, 2, 1, 2.

Capital letter Y (#164, page 28): Form all of *capital letter U* except final curve; continue descending straight line two spaces below baseline; inverted loop as in *small letter y*. Analysis of principles: 6, 2, 1, 4.

U Unua Unua Unua Unua Unua

Y Yearn Yearn Yearn Yearn Yearn

Capital letter I (#166, page 28): start on baseline; ascending left curve on main slant; short right turn; descending opposite right curve, crossing one-third space above baseline; finish with capital stem oval. Analysis of principles: 6, 7.

Capital letter J (#168, page 28): start on baseline; ascending left curve; short right turn; descending right curve crossing one-third space above baseline and continuing two spaces below it; short left turn; ascending left curve crossing at same point; ending one space to right of crossing. Analysis of principles: 6, 2, 3.

I Iron Iron Iron Iron Iron

J Jane Jane Jane Jane Jane

The *Seventh Principle* (#142, page 25), the Capital Stem: starting three space above baseline, descend slight left curve on oblique slant one and one-half spaces; reversed oval on slant of 15°; oval ends one-third space to left of descending line and one and one-fourth spaces above baseline. Practice the *Seventh Principle letters.*

Capital letter A (#171, page 29): capital stem; descending slight left curve; descending left curve starting one and one-fourth spaces above baseline; on crossing capital stem, finish with right curve. Analysis of principles: 7, 3, 3, 2.

Capital letter N (#173, page 29): form like start of *capital letter A* to point where left curve touches base; short right turn; ascending left curve two spaces high. Analysis of principles: 7, 3, 3.

Capital letter M (#175, page 29): form like *capital letter N* to its second point of contact with baseline; short right turn; ascending left curve; angular joining; descending left curve; ascending right curve. Analysis of principles: 7, 3, 3, 3, 2.

N Noun Noun Noun Noun Noun

M Man Man Man Man Man

Capital letter T (#177, page 30): capital stem starting one-half space from top line, first curve fuller than in *capital letter A*; ascending left curve one space left of top of stem; loop; horizontal right curve. Analysis of principles: 7, 3, 2, 3, 2.

Capital letter F (#179, page 30): Form capital stem as in *capital letter T* but continue upper curve of oval into right curve across stem; slight descending left curve; form cap of letter as in *T*. Analysis of principles: 7, 3, 3, 2, 3, 2.

Capital letter H (#181, page 30): ascending right curve; capital stem; oval as in *A*; descending left curve; finish like *A*. Analysis of principles: 2, 7, 3, 3, 2.

Capital letter K (#183, page 30): form first part like *capital letter H*; three spaces above baseline and two to right of stem, descending left and right curve; small loop at stem one and one-half spaces above baseline; descending right and left curve; short right turn; ascending right curve. Analysis of principles: 2, 7, 3, 2, 2, 3, 2.

Capital letter S (#185, page 31): ascending right curve one space; loop; descending right curve; end with capital stem oval. Analysis of principles: 2, 7.

Capital letter L (#187, page 31): form like S to point where descending right curve touches baseline; loop left one space long and one-fourth spaces wide; ascending right curve one space. Bottom loop should reach one-fourth space to left of first line of letter. Analysis of principles: 2, 7, 3, 2.

Capital letter G (#189, page 31): ascending right curve three spaces; descending left curve, crossing one space above baseline and continuing one-fifth space; ascending right curve to half height of letter; finish with capital stem oval. Analysis of principles: 2, 3, 2, 7.

Capital letter P (#191, page 32): start two and one-half spaces above baseline; descending left and right curve on main slant to base; left oval turn; ascending left curve on main slant three spaces; right oval turn; descending right curve, crossing stem one-half space from top and again at middle of letter, ending one-fourth space to left of stem. Analysis of principles: 7, 3, 2.

G Game Game Game Game Game

P Prime Prime Prime Prime Prime

Capital letter B (#193, page 32): form like *capital letter P*; narrow loop crossing stem; descending right curve into oval. Analysis of principles: 7, 3, 2, 2, 3.

Capital letter R (#195, page 32): form like *capital letter B* till loop; right and left descending curve; right ascending curve. Analysis of principles: 7, 3, 2, 2, 3, 2.

B Beam Beam Beam Beam Beam

R Rains Rains Rains Rains Rains

Ordinary	Ordinary	Objectives	Objectives

Emulated Emulated Exclaimer Exclaimer

Dousing Dousing Declaims Declaims

Cranesbill Cranesbill Calmer Calmer

Xanadu Xanadu Zinfandel Zinfandel

Quality *Quality* *Quicken* *Quicken*

Validate *Validate* *Verbatim* *Verbatim*

Western	Western	Window	Window

Unsavory Unsavory Unearths Unearths

Younger	*Younger*	*Yawning*	*Yawning*

Imprint *Imprint* *January* *January*

Audacity Audacity Architect Architect

Napkins Napkins Neatness Neatness

Mackerel Mackerel Minute Minute

Teaching Teaching Tribune Tribune

Festively *Festively* *February* *February*

Hamilton Hamilton Hilltop Hilltop

Kindness Kindness Kitchen Kitchen

Searching Seizing Searching Seizing

Luncheon Luncheon Leading Leading

Gratifiers *Gratifiers* *Gripping* *Gripping*

Penman	Penman	Parquet	Parquet

Barnard *Barnard* *Rampart* *Rampart*

Angels are guardian spirits.

Better to live well than long.

Criticize your own writing.

Doing nothing is doing ill.

Exercise strengthens the body.

Freedom is a precious boon.

Gaming has ruined many.

Hold truth in great esteem.

Industry increases wealth.

Justice holds equal scales.

Kind words can never die.

Let your promises be sincere.

Modesty always charms.

Nature is imitated by art.

Opinion misleads many.

Promise little and do much.

Quit not certainty for hope.

Reputation is not character.

Specimen of Spencerian

Practical Penmanship Student

Time present is our only lot.

Urania muse of astronomy

Virtue commands respect.

Wisdom is better than riches.

Theory *of* Spencerian Penmanship

Xerxes was a great general.

Youth should listen to age.

Theory *of* Spencerian Penmanship

Zenobia was a heroic queen.